FORGOTTEN FIRES OF CHICAGO

FORGOTTEN FIRES
OF CHICAGO

THE LAKE MICHIGAN INFERNO AND A CENTURY OF FLAME

JOHN F. HOGAN *and*
ALEX A. BURKHOLDER

Foreword by Robert Hoff

THE
History
PRESS

Published by The History Press
Charleston, SC 29403
www.historypress.net

Front cover, top row: All courtesy of the Ken Little Collection. *Front cover, bottom*: Courtesy of the Jim Regan Collection.
Back cover, inset: Courtesy of the Jim Regan Collection. *Back cover, bottom*: Courtesy of the Ken Little Collection.

First published 2014

Manufactured in the United States

ISBN 978.1.62619.747.3

Library of Congress Control Number: 2014953157

CONTENTS

CONTENTS

FOREWORD

When asked to write the foreword for Alex and John's book, I was honored. The many captivating and interesting stories researched and written here are part of the true, but many times tragic, history of the city of Chicago.

As I read the book, I could not help but think of the lives of the many firefighters and civilians who were killed or injured and the families and co-workers who were affected by these sometimes-avoidable incidents. Truth in journalism is at its best in this book. It touches the dark side of human error, politics and the arrogance of those who make decisions of life and death before an incident occurs.

It hit home hard for me because my family was involved in an incident that changed our lives. On February 14, 1962, my father, Chief Thomas A. Hoff, and Chief Robert J. O'Brien of the Chicago Fire Department were killed in the line of duty when the roof of a burning apartment building collapsed on them as they evacuated firefighters. My mother was left to raise six children, and that she did. But, as we learned, the building that killed my father and Chief O'Brien had many fire and building code violations written against it, all tied up in the court system. Was this avoidable? In my mind, yes, it was.

I was fortunate enough to follow in the footsteps of my grandfather, father and brother as a Chicago firefighter. In my thirty-five-plus years as a member of the greatest fire department, I experienced many incidents with positive outcomes but also many tragic incidents, including being severely burned

myself. In all of that, I found that history repeats itself, and we must learn from these events. We learn from past events to change the outcome of the next similar event.

I believe this book is a must-read not only for first responders but also all history buffs, especially those interested in Chicago history. It will capture your attention and your heart.

ROBERT HOFF
Retired Fire Commissioner
Chicago Fire Department

PREFACE

When we began work in 2010 on a book about Chicago Fire Department history, we envisioned a project about twice the length of this volume. After we finished, Ben Gibson, a senior commissioning editor at The History Press, recognized that we had, in fact, produced the contents of two separate books—one detailing the seemingly endless series of fires at the old Chicago Union Stock Yards and the other a compilation of additional spectacular events that have all but vanished from contemporary memory. The first installment became *Fire Strikes the Chicago Stock Yards: Flame and Folly in the Jungle*, which focused primarily on the disastrous fires of 1910 and 1934. This follow-up effort includes accounts of eighteen no-less-gripping incidents, as well as photos and captions of several more worth remembering.

As in the case of the earlier book, we benefitted greatly from the expert guidance of two men without peer in their knowledge of the Chicago Fire Department and its storied history—historians and archivists Ken Little, former senior fire alarm operator, and his longtime co-author and collaborator, Father John McNalis. They were exceedingly generous with time spent correcting text, ferreting out data and photos and offering encouragement. Father McNalis's help in assembling the image lineup proved invaluable. Both men are board members of the Fire Museum of Greater Chicago, our always reliable source of information and support.

We have been pestering Lyle Benedict and his staff at the Chicago Public Library's Municipal Reference Collection for years and apparently haven't worn out our welcome. Their professionalism and friendliness are deeply

appreciated. Paula Everett, president of Chicago's Mount Greenwood Cemetery, has been most generous in sharing her files and photo collection from the tragic 1909 Temporary Crib Fire, many of whose victims lie buried at Mount Greenwood. Arcadia Publishing author and Roosevelt University professor William R. Host kindly shared photos from his historic collection. Jim Regan deserves special mention for his photo contributions. We felt honored when Bob Hoff, the highly respected former commissioner of the Chicago Fire Department, agreed to write the foreword.

As with previous projects, John has striven mightily to relieve his editor in chief and spouse, Judy E. Brady, of her sanity. Fortunately, he has yet to succeed. Thank you for the customary superb contributions, B.K. Likewise, Barbara Burkholder has endured another go-around with patience and good humor for which Alex offers his gratitude.

1

FIRE AND ICE

THE LAKE MICHIGAN CRIB INFERNO
JANUARY 20, 1909

Lake Michigan in January, a mile and a half offshore, is forbidding territory, home of the mythical Hawk that swoops toward land on wings of ice. During particularly frigid winters, the lake can freeze over that far out and much farther. On the gloomy morning of January 20, 1909, the water was open a mile and a half out except for bobbing chunks of ice the size of small flotation devices. A light fog lay over the surface, seeming to defy a brisk south wind.

Off Seventy-first Street, man had invaded the domain of the Hawk by imposing an intermediate wooden intake crib, two stories above water level, six-sided and 88 feet across. The structure had been built on shore and towed into the lake on July 18, 1907. There it was sunk 33 feet to the sandy bottom and fitted into a base of vertically placed timbers extending 6 feet above the lake bottom. Likened to a Civil War fortress, it was built to withstand waves and ice—but not fire. Approximately 106 workmen, many of them itinerants, called the intermediate crib home. Their job was to construct a tunnel to connect water distribution facilities on shore with a permanent intake crib farther out in the lake at Sixty-eighth Street, which was completed in 1908. A 23-foot-wide shaft, lined with steel to make it waterproof, extended downward from the temporary crib, through water and sand, into the Niagara limestone bedrock that was being blasted to form the tunnel some 135 feet below the lake surface. Work proceeded in both directions. By January 1909, the tunnel had advanced some 400 feet toward shore and 200 feet toward the permanent crib under miserable working

conditions. The tunnel, 14 feet in diameter, was crowded with perspiring men breathing bad air, pumped in from above and made worse by the lingering odor of exploded dynamite. Water dripped continually. The entire project was being built at a cost of $1.7 million.

The intermediate crib provided Spartan accommodations—eating and sleeping quarters for the men, space for the storage of materials and not much more. It was connected to shore by an aerial tramway supported by twenty-four four-legged steel towers. The towers, which rose thirty-five feet above the water and were spaced about three hundred feet apart, supported two pairs of cable, one pair for each direction. The latticed towers and their cables resembled small electrical transmission towers and lines. Along the cables ran a series of ten steel baskets, each capable of ferrying four men, a like amount of supplies or about one thousand pounds of excavated limestone between crib and shore. A one-way trip took about half an hour. George W. Jackson, owner of the firm constructing the tunnel, had devised the tramway because boat dockings at the crib in bad weather were considered extremely hazardous, if not downright impossible. It was also more economical to keep the workers housed on the crib.

On January 20, 1909, as all days, the men worked in two twelve-hour shifts around the clock. With the dawn of another day, dark as it was, the shifts were changing. Some men were sleeping at about 8:00 a.m. in the second-floor bunk quarters while others were eating breakfast in the mess hall. Several dozen members of the day shift were already at work or about to start in the tunnel. Others were coming out, shedding their work clothes and washing up. According to drill runner Logan Miller, he and his partner, William Summers, had just gotten off the bucket elevator at the top of the shaft and met co-worker Nathan Fultz

Logan Miller pointed the finger of guilt for the crib fire at a fellow worker. Later, he had second thoughts about his accusation. *Courtesy of the Mount Greenwood Cemetery Collection.*

preparing to go down. Something, perhaps a slight burst of steam, blew out of the torch Miller was carrying. He said he handed it to Fultz, who re-lighted it while mentioning that the men below didn't have enough dynamite powder to create the blast they wanted. Miller said Fultz turned and carried the torch into the powder storage room, where anywhere from two hundred pounds to three tons of dynamite—depending on whose estimate is believed—were stored directly below the bunk room. (The city public works department's two-hundred-pound estimate seems far more credible.) According to Miller, Fultz came out of the powder room just as fire broke out. "I stood near the powder room and [Fultz] opened the door," Miller related. "The blaze came right up. I knew there was nothing burning three minutes before." Miller's version was corroborated by Summers and electrician Charles Rose, but Fultz claimed that he didn't know how the fire started. An experienced thirty-seven-year-old driller and blaster, Fultz denied having gone into the powder room. Instead, he said he and his partner, George Chidlaw, also thirty-seven, were about to go down in the shaft when they noticed black smoke.

"We thought it was the blast in the tunnel…There were ten or twelve other men standing around us, and I remarked, 'Look at that smoke coming up there.' One of the fellows said, 'Well, I'm going to smoke my pipe and make some more smoke,' in a joking way, and we all laughed." Fultz and Chidlaw then descended. "We had been down in the tunnel only a short time when I noticed it getting awfully hot and felt the heat on my hands and face. The bucket in which we had been lowered had been pulled up, and I said to my partner that something wrong must have happened." They decided to wait for the next bucket, which never arrived. "The smoke got so thick that we could hardly breathe and our eyes began to smart and run water. My partner put his hand on my shoulder and said, 'Nathan, something surely must have happened up in the crib. This smoke is awful, and I know I can't stand it much longer."

Within minutes, the crib had become a furnace. "There was so much smoke we couldn't see how to get out," Miller stated. "We couldn't use the hose, because if powder is hit with water, it will explode if it's hot." There was, in fact, no explosion. A chemist testified later that dynamite will burn eight times as fast as pinewood but normally won't explode without a concussion. If the crib had exploded, according to Chief Fire Marshal James Horan, debris and floating body parts would have been the only things that greeted rescuers.

When the fire was discovered, someone picked up the telephone and called the Jackson Company's field office on shore: "The crib is on fire.

For God's sake send help at once or a dozen or more of us will be burned alive. The tug…" At that point, fire severed the phone line, but the frenzied message came across all too clear. The tug mentioned was the company boat *T.T. Morford*, tied up at the Sixty-eight Street crib, half a mile away. Second in command Joseph Landon spotted the greenish gray smoke first.

Captain Edward Johnson, already a ten-year veteran lake skipper at age thirty-five, ordered full speed ahead through the churning waters. "When I neared the crib," Johnson recounted, "I saw a number of the men, their clothes ablaze, run towards the end and jump into the lake. Others rapidly twisted ropes about anything they could and jumped into the water to prevent being burned alive. Others picked up boxes or whatever they could find and jumped into the lake. Many others huddled about a corner of the crib, out of the way of the flames." The four minutes Johnson and his crew of four took to reach the scene were the longest of his life, he declared. Along the way, they blasted the *Morford*'s whistle to let the men struggling in the icy water know that help was on the way.

When they came within fifty feet of the crib, captain and crew began throwing ropes, life belts, boxes, kegs—anything that would float—to the men in the water. Some of the workers clung to chunks of ice. "The cold, icy water caused them much suffering," Johnson continued, "and some of them would have drowned sure if we had not reached over and dragged them in…I reached over and helped one or two of the poor fellows into the boat. They were almost frozen through, and we rushed them down into the little boiler room. We were picking up these men as fast as we could…About a dozen or more were on the crib, yelling for us to hurry and take them off. They seemed to have gone crazy with fear…We picked up those who were hanging on the end of ropes. When the boat touched the crib, some of the men jumped on the tug, but others seemed too afraid to do anything." These men apparently failed to realize that the *Morford* had come to save them. Johnson had to jump out and almost throw them in the tug. Others clung to their cakes of ice. The crew had to pry them loose and drag them on board. Men of an opposite mindset grabbed one side of the tug and pulled so heavily that the craft nearly capsized. More were lying around the crib, suffering from burns. Still others were crawling out from different parts of the flaming structure, their clothes ablaze. Everyone taken on board was moaning from burns or chattering from the cold. Several had been burned as well as half drowned. Their grimy faces stared out from under the blankets in which the crew had wrapped them.

If it were not for the quick action of the crew of the *T.T. Morford*, the number of fatalities would have been much higher. *Courtesy of the Mount Greenwood Cemetery Collection.*

One of the men picked up was Edward Skinner, who said he'd been hurled to the crib floor by what he called an explosion.

> *I was walking near the powder storeroom when all of a sudden there was an awful roar, and I felt the building shake from top to bottom. I started to run for the water, but I hadn't gone far when there was a second roar, and I was hurled against the floor. I managed to get up, but I saw a dozen or so others scrambling on the floor. I managed to get out before the flames reached me. The smoke was so thick I could hardly see. The heat was something awful. I knew it meant certain death to remain, so I plunged into the lake…I was in the water only a few seconds when I saw others jumping into the water from the burning crib…I must have been in the water a long time when the tug came to the rescue. Someone threw out a rope and I caught it and pulled myself in. Others got into the tug after me in the same way.*

Skinner escaped with burns to only his hands and face.

As the terrifying scenes transpired a mile and a half out in the lake, other scenes of desolation and sorrow were taking place on shore. From Seventy-first to Seventy-fourth Street, a large crowd formed and watched helplessly from the ice-covered embankments. Many were loved ones of the men on the crib. Hearing of the catastrophe, frantic women rushed to the lakefront with their children in tow. One woman said, "I was eating breakfast when I saw the flame on the crib from the kitchen window. In a moment, I realized what had happened." Some in the crowd jostled one another to get a better look at the burning crib and perhaps catch a glimpse of a husband, father or brother. Many of the women sobbed hysterically. Virtually all offered silent prayers.

About the time Captain Johnson believed that he and his crew had rescued all the injured, two small explosions rocked the crib and tossed the *Morford* around like a cork. Heavily overloaded with forty-eight victims, the tug withdrew. Nineteen men with less severe injuries were dropped at the Sixty-eighth Street crib to be picked up later. Again plowing full speed ahead, the blunt-nosed *Morford* carried the badly burned and those with other injuries to the Chicago River, where ambulances would pick them up at the former Rush Street Bridge and transport them to hospitals. Awaiting his turn, driller Jake Walpole said, "I'd like to get warm once more, if ever that time comes around. It isn't much more than an hour since the accident happened, and yet it feels as if I had been floating around in the lake for the last month. I'm so cold. I'm broke, too." The run downtown had taken thirty-seven minutes. Johnson mentioned that he didn't see any bodies in the lake before he left. The *Morford*'s place at the scene was taken by the fireboats *Conway* and *Illinois*, dispatched by Chief Horan to extinguish what was left of the fire. Each had been moored about ten miles away, the *Illinois* in the Chicago River and the *Conway* in the Calumet River. There was no way either could have reached the temporary crib in time to save lives.

Two sets of victims never stood a chance—fourteen sleeping in the second-floor bunkroom, who apparently didn't hear the alarm and got cremated in their beds, and twenty found at the bottom of the shaft, their deaths hastened when fire cut off the pipe supplying them with fresh air. Those left alive, at least temporarily, had practically no time to decide how to save themselves. Their choices were grim and grimmer. Much depended on where they were when the fire broke out. The luckiest were able to jump onto a large mud and gravel pile rising eight feet out of the lake, about ten feet from the crib. Here they found accumulated residue piled high, the heaps of debris carved by the drilling and blasting. So many men scrambled for a place on the slippery stone and earth that some lost their footing or got pushed into the

lake. A few sank before they could be pulled back by companions. Those able to hold their footing got picked up by the *Morford* as licking flames from the crib threatened to drive them into the water.

Most of the men on the stone pile, like others who jumped out of windows, were naked or wearing next to nothing. That's the way they slept. When the fire struck, their only impulse was to rush for open air, and the quickest route was through one of the crib's nine windows. Men desperate for a way out were drawn in bunches to the windows on both floors, pushing and clawing for the chance to be next in a succession of jumpers who had determined to risk drowning rather than meet certain death by fire. Some who leaped into the water from the first floor escaped through the south door. The opened door and windows created a draft that caused the fire to spread even more quickly. Anyone who tried the west door, near the dynamite stockpile, found his way blocked by a sheet of flame. Of the men who bailed out of the second floor, some landed on blocks of ice. Others swam to the floes with great difficulty, only to find more trouble trying to flop on. Not all those who could find a floe were able to survive. Some held on as long as they could and then sank beneath the surface. A few attempted to swim to shore, a mile and a half away. One got as far as two blocks before clinging to the base of one of the tramway towers. He was rescued by the *Morford*. As for the tramway itself, it proved useless as a means of escape because the flames knocked out its connecting cables. It likewise proved useless to firemen or other would-be rescuers.

The crush of humanity trying to reach the windows left some at the back of the pack. One of these men shouted, "The tunnel! Down to the tunnel!" And so they rushed for the shaft in the hope of riding out the inferno more than one hundred feet underground. It seemed like a brilliant idea. An undetermined number of men jammed into the car and rapidly lowered themselves to the bottom, joining those already down there to work. Those left behind either were overcome by smoke or burned to death. But the men who had descended soon realized that their supposed safe haven was in reality only another death trap. Gas and smoke began to fill the tunnel. Showers of sparks from the fire above rained down. The compressed air tube, used to carry fresh air to workers in the tunnel, came crashing down along with the cables and apparatus of the elevator car. The trapped men retreated into the two wings of the tunnel, hundreds of feet from the base of the shaft. Water began leaking into the chamber, creating a new hazard. Inch by inch, it rose until it reached knee-high. In the end, however, it was the gas fumes and smoke that claimed the men. Twenty bodies were recovered, men who had been working below and comrades who joined them in panic, bringing

horrific tales of what was happening above. No one could have survived in the tunnel, it was believed.

By the time the fireboat *Conway* steamed down from South Chicago, the crib was still blazing. "We got the alarm at 8:30 a.m. and got up to speed immediately," said the boat's commander, Lieutenant James Tobin. "It took us two hours to go two miles. We had to break through ten inches of ice in many places. Nobody could have lived in [the fire] a second." After the *Conway* and the *Illinois* brought the flames under control, firemen made a final check in the hope of proving Lieutenant Tobin wrong. Surviving workers held out hope that by some miracle, comrades who were working in the tunnel or had ridden down the shaft might be clinging to life. Firemen called for volunteers to go down and learn what had become of those below. Only one of the workmen, Gustav Rolson, stepped forward. A rope was tied around his waist, and he was lowered into the faintly smoking pit. Rolson had been at the bottom only a minute when he pulled the signal cord and was rapidly drawn to the surface. He was totally exhausted and short of breath. After reviving in the fresh air, Rolson told of smelling gas that seemed to get stronger the deeper he went. "Then I felt water at my ankles and the next thing I knew I was standing knee-deep in it, on the bottom of the shaft. The fumes of smoke and the gas were overpowering. I could see nothing, but…I could hear low, heart-rending moans. Yet, I was powerless to aid the poor fellows who I knew to be close at hand. I felt myself succumbing to the gas and jerked the signal cord. I called out. Only groans answered me, a trifle louder than before."

The pumps on shore that forced compressed air into the tunnel were reactivated. When the tunnel had been cleared of fumes, George Curtis, master mechanic at the Sixty-eighth Street crib, and William McIlhenny, went down the shaft in a bucket. In the tunnel, close to the compressed air pipe, they found the unconscious form of Nathan Fultz, who had been entombed for eight hours. Fifty feet away, they discovered the lifeless body of Fultz's partner, George Chidlaw. Fultz was raised to the surface, put aboard the *Morford* and rushed to a hospital in South Chicago, where he remained unconscious for seven more hours. Thus, the last man taken alive from the crib turned out to be the one accused of starting the fire. From his hospital bed, Fultz said, "It seemed to me like hours. I got so weak that I was forced to let my partner lie. I remember that I fell and crawled along on my hands and knees. The air seemed like flame…I groped along through the smoke, feeling the wall with my hands, until I came to an opening in the rocks. It was damp and cold and I shoved my head into the place. There was just about

enough room…but I kept my head in the hole against the cold rock." Fultz made a complete recovery. He continued to insist that he never set foot in the powder storage room.

Initially, forty-seven bodies were recovered. The grim task of removing some of them from the crib fell to the city tugboat *Sabin*, whose crew of firemen and volunteers transported the remains of fifteen men to the Sixty-eighth Street crib. The fireboat *Illinois* took the remains of seventeen other victims downtown. Each had been burned beyond recognition. Later discoveries brought the toll to fifty-six, in addition to an estimated twelve men who drowned before the *Morford*'s arrival. Authorities agreed that the exact death toll would never be known, but they put their most careful calculation at seventy. Coroner Peter Hoffman, in consultation with the victims' families, determined that the most humane course would be to bury forty-seven sets of remains in one giant grave. The flames had caused such mutilation that even counting the number of bodies became impossible. The best the coroner and the police could do was to compare the list of the missing against the names of the survivors.

January 23, 1909, the day that the remains of forty-seven victims were laid to rest, saw the warmest temperature—fifty-nine degrees—ever recorded

The headstone at Mount Greenwood Cemetery identifying the burial site of crib fire victims was finally placed there ninety-two years after the conflagration and paid for by the cemetery itself. *Courtesy of the Mount Greenwood Cemetery Collection.*

on that date. The day began with a requiem high Mass for the laborers who may have been Catholic at the Church of the Immaculate Conception, Eighty-eighth Street and Commercial Avenue. One black, empty casket symbolized the deceased. In the early afternoon, a huge procession formed at the South Chicago police station. Some two hundred officers, along with grieving families, thousands of additional mourners and city and company officials, followed forty-seven hearses through the streets of South Chicago, forming a multitude that stretched from curb to curb. Residents gathered on their porches to view the procession. The cortege then began the long journey to Mount Greenwood Cemetery at the southwestern edge of the city, where simple graveside services were conducted. The caskets were placed in rows in the single forty-one- by thirty-six-foot grave. Throngs of curiosity seekers, some hanging from trees, witnessed the mass burial. The construction company owner, George Jackson, paid all funeral expenses and for the purchase of the burial plot, which lies along the eastern border of the cemetery. Today, it stands across the street from a row of attractive, single-family brick homes in the 10900 block of South California Avenue. One item that Jackson overlooked, perhaps conveniently, was a headstone. It's understandable that he'd want the tragedy forgotten. For ninety-two years, the mass grave remained unmarked. Then in 2001, Mount Greenwood Cemetery president Paula Everett concluded that "there should have been something there after all these years." At its own expense, the cemetery placed a one- by two-foot flat headstone atop the grave. The inscription reads: "In Memory of Crib Fire. 45 Unknown Men. Jan 20, 1909." The number on the gravestone notwithstanding, forty-six victims lie buried at the site, according to Everett. She said five others who subsequently were identified also are buried at Mount Greenwood.

Chicagoans could have written the next chapter before reading it in their newspapers. No sooner had the coroner's inquest convened four days after the funeral than a number of witnesses were describing the crib as a firetrap. No quarrel there, but who bore responsibility? As usual in such cases, volunteers proved scarce.

On the first afternoon of the inquest, Coroner Hoffman and state's attorney John Wayman accompanied the jury, various officials, witnesses and the press on an inspection of what was left of the crib. They traveled to the scene aboard the same city tug used to remove the bodies. Asked by one of the jurors if there had been any fire extinguishers, George Jackson replied, "Fifty-six." A search turned up the remains of one. What about a lifeboat? Jackson said nothing, but city engineer John Ericson volunteered

that "they never had such a boat here." As a matter of fact, no flotation devices of any kind—boats, rafts, life preservers—were kept at the crib. A juror asked why so many men died near the mouth of the shaft. "It is my theory," the company owner replied, "that the men stampeded and saw only two ways of escape—the lake and the shaft. When they reached the tunnel shaft they died. The fire did not go more than ten feet down the shaft."

Engineer Ericson explained that "there were five pumps, life preservers and some other precautions, but of course, these were not under our supervision." As to the explosives used, he said, "That was not under my supervision, but under that of the fire department."

City inspector Richard Goggin, on duty at the crib at the time of the fire, declared that he had nothing to do with precautions governing powder and dynamite. Goggin further stated that no one at city hall had ever heard of city representatives checking the sleeping quarters of the men for safety and sanitary conditions.

As if to underscore the cynical adage that no good deed goes unpunished, Coroner Hoffman and Attorney Wayman bombarded Captain Johnson with hostile questions that suggested he might have been able to save more lives if he'd kept the tugboat closer to the temporary crib. Johnson disputed that theory because of the rapid spread of the fire. Asked if there were times when the temporary crib was left unprotected, the captain conceded that there were, while pointing out that the *Morford* was required to make supply runs to the city, deliver coal to the Sixty-eighth Street crib and break ice. The tug's assignment, he reminded the officials, was to provide general utility service and not remain at the temporary crib at all times.

Another witness who came in for a grilling, the crib's drill boss Francis Nolan, testified that the powder storage room was left unlocked. Nolan, who escaped the fire by way of the rock pile, revealed that four uncovered, fifty-pound boxes of dynamite lay on the powder room floor at the time of the fire. He mentioned that one of the janitor's duties was to spread out hundreds of pounds of dynamite to be thawed by steam pipes before he equipped the sticks with exploders.

Crib engineer Peter Blake told of asking inspector Goggin, not long before the blaze, if there would be a fire drill "like they have on ships." Blake said Goggin just laughed.

In less than twenty-four hours, Nathan Fultz had evolved from an obscure tunnel worker to someone who had narrowly escaped a horrible death, watched helplessly as a friend and co-worker died at his side, stood accused of starting a fire that killed scores of men and found himself

in police custody. A week later, on the second day of the inquest, the driller's luck began to change. Fellow employees Logan Miller and William Summers, who claimed they saw Fultz carry a lighted torch into the powder storage room, began to have second thoughts now that they were testifying under oath. Fultz held to his story that he never set foot in the powder room but went straight down the shaft. His version gained support from another co-worker, coal handler David Slight, who said he did see a man with a "torch in his hand just before the fire, but that man didn't get off the elevator on the first floor. Almost simultaneous to his sighting, Slight testified, the powder room erupted. Fultz suggested that Miller and Summers, who lived at the same address, had accused him because of an old grudge. Coroner Hoffman had heard enough; he ordered Fultz released from custody.

The verdict of the coroner's jury two and a half weeks later took many by surprise. Conventional wisdom—at least that dispensed by the daily press—held that the Jackson Company would be found responsible for the loss of sixty lives. (The final toll had been reduced from seventy.) Conventional wisdom proved wrong. The jury exonerated the company, George Jackson personally and the City of Chicago from charges of criminal carelessness. While somewhat critical of safety procedures at the crib, the jury found itself unable to determine the cause of the fire. In addition to the presence of a lighted torch in the powder room, two other theories were discounted: that a steam line ignited the dynamite or that gasoline, poured into cracks in the woodwork to kill bedbugs, became ignited. The panel recommended that the mayor appoint a commission to suggest rules and regulations for handling dynamite and other explosives.

From his office, Jackson declared that the temporary crib would be rebuilt along the same lines "as soon as the city authorities give us the word to go ahead. It was a practical crib. Even if it had been built of steel, it would have had no effect in saving life…Indeed, with steel the disaster might have been worse." The crib did get rebuilt—with wood—and stood for almost another three years. Workers, however, were no longer housed on the structure. The water tunnel under the lake was completed in late 1911, opening the way for elimination of the crib under the original terms with the federal government. And so, on November 6, 1911, fire destroyed the crib a second time. On this occasion, the blaze was intentional, deemed the most practical way of getting rid of the structure. The fire so closely resembled the 1909 catastrophe that observers on shore telephoned the police and fire departments to ask whether anyone had been killed or injured.

The ill-fated intermediate crib might have disappeared from view above the water line, but thirty or so feet below, its legacy lives on. For years, the foundation and various artifacts have provided a fascinating exploration site for SCUBA divers. "Not just shipwrecks are interesting," explained Tony Kiefer of the Underwater Archeological Society of Chicago. Kiefer and his associates have made a detailed study of what's down there. The centerpiece is something the divers call the "dance floor," the flat, smooth hexagon base of the crib, which measures seventy-eight by eighty-eight feet. Surrounding the dance floor are six layers of one-foot-square timbers that rise six feet above the lake bottom. Piles of rock debris are clustered around the perimeter. The divers have found support beams, along with wheels, sections of cable and one of the cars from the tramway. Also in the vicinity rest two five-foot-long cars that ran along a narrow track and were used to remove debris from the tunnel. All of the remnants are thickly encrusted with algae and zebra mussels. Kiefer and his teammates have taken extensive photos reminiscent of those showing artifacts of the *Titanic* or other sunken ships. The tunnel was sealed about the time the last of the crib was intentionally burned, but the job shouldn't have ended there, according to Kiefer. George Jackson's agreement with the Army Corps of Engineers called for him to remove the foundation and restore the lake bottom. Apparently, the corps never pressed the issue.

After the fatal crib fire, Jackson tried to get the city to cover the costs of implementing the new safety requirements mandated as a result of the disaster. He found a number of sympathetic aldermen, but the city council ultimately turned down his request. Regardless, the fire apparently didn't harm Jackson's standing with the city. In 1910, his company rebuilt the Washington Street tunnel under the Chicago River and remodeled the Loop elevated structure. The following year, Jackson's company flirted with insolvency but recovered. He blamed its problems, in part, on the 1909 fire.

On the thirty-seventh anniversary of the crib fire, January 20, 1946, the *Chicago Tribune* ran a feature on Joe Landon, believed to be the only surviving crew member of the *T.T. Morford*. The seventy-nine-year-old sailor said, "For years afterward I could hear the screams and groans of men trapped in the crib and others who had jumped into the lake or climbed out on floating ice cakes."

2

THE SECOND GREAT CHICAGO FIRE

JULY 14, 1874

Condemned to repeat the mistakes of the past, Chicago entered the summer of 1874 with some all-too-familiar nemeses in place—namely a prolonged dry spell, strong southwest winds and a close concentration of highly flammable buildings that had escaped the Great Fire of 1871. The city might have rebuilt the central area but to the south left it hostage to the same type of construction that had threatened and ultimately destroyed it from the west less than three years earlier. "No persuasion or appeal to a sense of civic duty could induce the owners to replace the tinder-like structures with brick buildings," fire historian James McQuade observed. "What moral suasion [sic] and civic pride failed to perform, the fire of July 14 accomplished in a thorough manner."

The fire started in late afternoon in a peddler's shanty near Clark and Taylor Streets and rapidly tore through an overpopulated area defined by narrow streets and wooden structures filled with rags, paper, lard oil and other combustibles. Arson or spontaneous combustion was suspected. Flames quickly spread to a nearby oil refinery. Aided by the dry conditions and strong wind, the fire began to spread north, consuming frame houses and other buildings and endangering the downtown business district, much of which had been rebuilt after the 1871 fire. Chief fire marshal Matt Benner, who had replaced Chief Robert Williams in 1873, came under criticism for attacking the blaze from the south while the flames were spreading north. After reformulating its attack, the fire department failed in an attempt to stop the flames at Polk Street and then moved farther north to Harrison

The 1874 conflagration left a path of destruction more than half a mile long. If they had not been stopped where they were, the flames could have destroyed much of the downtown area rebuilt after the great conflagration three years earlier. *Courtesy of the Fire Museum of Greater Chicago.*

Engine 21 was one of the first steam pumpers on the scene in 1874 and was the first Chicago fire company organized with black firemen. The engine's first foreman (today, it would be captain) was David Kenyon, who was white and is seated in the middle of the first row. Kenyon is best remembered as the inventor of the firehouse sliding pole. *Courtesy of the Frank McMenamin Collection.*

Street, where it met with some success. The fire continued to spread up State Street before it was finally stopped just north of Van Buren Street at 3:30 a.m. the following day. It had claimed forty-seven acres and an astonishing 812 buildings between, roughly, Clark, Taylor and Van Buren Streets and Michigan Avenue to the east. The neighborhood was home to the largest segment of the city's African American population. Fire losses amounted to $3.8 million, of which $2.2 million was covered by insurance. Despite criticism of his leadership, Matt Benner remained chief until 1879, when Denis Swenie reclaimed command.

Just as a massive fire the day before had been eclipsed by the Great Fire, the so-called Second Great Chicago Fire reversed the pattern and overshadowed another major, though less catastrophic, blaze on July 15. That fire burned "only" twenty-five buildings in the vicinity of Milwaukee Avenue and Sangamon Street. Did the city learn anything this time? Lamentably, the *Chicago Tribune* replied with an emphatic no. In an editorial, the paper said, "Would that we could say this is the last of such mad folly. It is not. Chicago still has thousands upon thousands of wooden shanties to feed future fires;

and go down they will all in good time. The utmost we can do is to prevent our stone and brick edifices from going down too." The editorial also scolded the insurance companies for enabling the sins of the past and urged them not to cover any new wooden buildings, make the owners of such existing structures pay for half the redeemable value of their policies and demand a reorganization of the fire department. Apparently, the carriers already were thinking along these lines because on the same day, the Chicago Board of Underwriters, meeting at the command of the national board, adopted a resolution calling for the department's reorganization with total authority placed in the hands of the fire marshal; regulations created against frame structures; the demolition of wooden awnings, cornices and cupolas; the prohibition of combustibles; and the enlargement of water mains.

Not knowing, or more likely not caring, about the desultory ways of some public officials, the National Underwriters got tired of waiting. On October 1, 1874, the group adopted a resolution calling on individual carriers to depart the city. Depart they did. In short order, all the demanded reforms got adopted, and all the insurance companies were back in business in Chicago by early December.

Later in the month, the *Chicago Tribune* weighed in with a final word about fire insurance, lambasting the owners of well-off businesses and properties for trying to secure lower rates by demanding superior fire department protection in lieu of spending "an additional one percent on the first cost of their buildings for permanent protection against fire." The paper complained that "these people want to transfer the cost of their insurance to the general taxpayers; making every tenth man a policeman, fireman, patrolman, watchman, or telegraph operator." It's the old story, the paper continued, "of depending upon somebody else to do what you can do infinitely better and cheaper yourself." This is the attitude of wealthy men, the editorial concluded, who "own marble palaces with shingles or tar roofs, and place their faith in fire engines and fire officers" while they themselves are attending balls or go "off shooting ducks."

3

TERROR AT THE WORLD'S FAIR

THE COLD STORAGE FIRE
JULY 10, 1893

At least one year before Chicago was declared the official site of the World's Columbian Exposition (the third of four stars on the city flag) in April 1890, its citizens began making plans to welcome the world. Chicagoans were eager to show how their city had risen from the rubble of 1871 to become a major young metropolis, ready to step onto the world stage. On May 10, 1893, the gates of the magnificent White City in Jackson Park were thrown open, and over the next five and a half months, 27 million visitors would stop by to pay their regards. But fire wasn't through putting its imprint on the city, try as the city might to distance itself from 1871. The months leading up to the grand opening offered an ominous prelude. Twice in January and once in April 1893, serious fires struck—two on Michigan Avenue—leaving three dead and total losses of nearly $400,000. In each of the January fires, a Chicago fireman was killed. In April, one day apart, two more died in the line of duty. These occurrences represented forerunners of not one but three dark events that would tarnish the fair itself.

In 1893, 984 men wore the uniform of the Chicago Fire Department, while 46 non-uniformed personnel brought the total force to 1,030, all under the command of the redoubtable Denis J. Swenie, born in Glasgow of Irish parents in 1834. The department under Chief Swenie held responsibility for four fireboats; eighty steam engines; three hand engines; thirty-one hook and ladders; one hundred hose carts, carriages and wagons; sixty-nine chemical extinguishers; thirty-one portable pumps; one water tower; and 466 horses.

All the department's horses and men couldn't have prevented what happened on July 10, when brave firefighters became fatally exposed to the ultimate results of construction that was ill-conceived at best and criminally negligent at worst. After the tragedy, four Chicago firemen and eight members of the World's Fair force lay dead, with another twenty firemen injured, one crippled for life. Three civilian workers were also killed. Three of the eight World's Fair victims were Chicago firefighters on leave from the department and serving in higher rank. Everyone agreed that the fair's cold storage warehouse was a firetrap whose design all but guaranteed disaster.

Exposition directors had granted permission to the Hercules Iron Works to construct and operate a facility to manufacture ice and preserve various foods. The lower floors contained refrigeration equipment and storage facilities while the upper floors housed a skating rink, dance hall, dining room and kitchen. Later, insurance company representatives revealed that the facility's flaws had appeared obvious, which explained why they canceled their coverage a month before tragedy struck. The building's two-hundred-foot-tall iron smokestack, fire historian James McQuade wrote, was enclosed by a wooden cupola whose top exceeded the end of the pipe. The stack should have been encased in a cast-iron thimble, according to the architect's plan, extending above the ornamentation to protect the woodwork of the cupola from the sparks of upward blasts. The thimble never got built, an omission McQuade denounced as "criminal negligence." Even though exposition directors had approved the plan for the ice house, neither they nor anyone else was held personally responsible. A spokesman for one insurance company declared, "Someone blundered and blundered badly…It was the general understanding among insurance men that the building was a fire risk and not worth the powder to blow it up." The boilers were too small and pushed to do more than they could handle, the insurance man maintained. The furnace, extended beyond capacity, sent abnormal amounts of heat up the smokestack, which became red hot and fired sparks at the ornamental wood surrounding it. "It was only a question of time when the building burned to the ground…There was no secret. The matter was known days ago."

His mention of "days ago" referred to a small fire that broke out in the cupola on June 17, the latest in a string of small blazes in that part of the building. Those fires raised warning flags in the fire department and among the carriers, both of whom dispatched high-level inspectors. The department's inspector, Captain James Fitzpatrick, would suffer fatal injuries in the July 10 inferno after detailing the very construction defects that would lead to his death. Captain Fitzpatrick and his insurance colleague reported

that the cupola formed a dangerous receptacle for cinders to collect and await a spark to ignite them. Chief Swenie conducted a follow-up inspection and reached the same conclusion. The insurance carriers, some skeptical even before the inspections, promptly canceled coverage. The owner of one carrier who had visited the exposition several times during construction said, "I thought at the time that [the cold storage building] was as poorly constructed a firetrap as I ever saw…When I found out that our firm had a small line of the building, the policies were canceled at once." Battalion Chief Edward Murphy was even more forthright. Speaking to an underwriters' committee on the Fourth of July, Murphy predicted that the building would

The World's Fair ice warehouse with the concealed smokestack in the tower. That tower would claim the lives of a dozen fair and city firemen. *Courtesy of the Fire Museum of Greater Chicago.*

be destroyed within a month. "That building has given us more trouble than any structure on the grounds. It is a miserable firetrap and will go up in smoke before long."

And yet, the cold storage warehouse remained in operation, as if awaiting the inevitable, which happened on the two-month anniversary of the exposition's opening. Some 130,000 visitors filled the fairgrounds that afternoon when a small fire again broke out in the cupola. The first alarm, at 1:32 p.m., brought a fire company stationed on the grounds. A tower that rose from the roof linked the top of the building to the cupola. Fifty feet up the tower began an ascending series of three platforms, each supported by columns that had a vague resemblance to the Leaning Tower of Pisa. The highest platform ended just ten feet below the cupola. The flames at the top of the cupola seemed insignificant at first but quickly curled their way downward, setting the wooden columns ablaze. At this time, Captain Fitzpatrick began leading a party of men toward the first platform. Behind them came more firemen, under the command of Captain Thomas Barry, who also had reached the roof, seventy feet above ground, by climbing an inside stairway. From there, all of the men proceeded to the tower balcony along a spiral staircase. Fitzpatrick, Barry and their men made their final ascent by way of wooden ladders nailed to the inside of the tower. They themselves carried no ladders, only a few coils of rope that they used to raise a hose. So far, so good, but all the while, the flames were slowly consuming the cupola. Chunks of blazing wood fell into the base below the platform that the firemen had reached. About ten minutes later, the men noticed puffs of smoke rising below their feet. At the same time, they felt heat coming from below as well as above. Firemen on the roof sensed the extreme danger about the same time as their nineteen comrades in harm's way. "When we got within twenty-five feet of the top of the tower, we realized that we were trapped and that the tower was bound to collapse," Barry related. "We were cut off completely." The crowd of at least twenty-five thousand fairgoers who had gathered to watch the men fight the fire realized the same thing. As the firemen on the roof shouted warnings to those on the platform, cries of horror went up from the spectators. Tongues of flame were lapping upward, just below the platform. Obvious to all, particularly the trapped men, was the fact that they found themselves caught in a vise of fire.

As the flames swept higher, John Davis, one of the exposition firemen, had a bold idea. He leaped for the hose line the men had pulled up with ropes, caught it with one hand, and shot down into a sea of flames. Clothes on fire and badly burned, Davis held tightly to the line and managed to lower

himself to the roof, where he was met by firemen who lowered him to the ground. He survived serious burns to his hands, arms and leg. Firefighters William Mahoney and Frank Bielenberg wrapped their arms around each other's torsos and began a descent from the balcony on a line of hose but fell about twenty-five feet above the roof. Both were injured but made full recoveries. Why none of the remaining trapped men followed this strategy will never be known. For some reason, they hesitated a minute—all the time required for the fire to burn the hose line in two. Captain Fitzpatrick shouted something to the men. One by one, they slowly crept around the balcony to the north side, where the fire had not yet attacked. When the last man arrived, a cheer went up from the crowd, but their hope didn't last. The flames followed. One last chance remained. Someone lowered a rope that almost reached the roof, but before anyone could grasp it, this lifeline also burned in two. The men faced two choices; leap seventy feet through the flames or burn to death on the platform. Shrieks and groans went up from the crowd. Women fainted. A well-dressed man fell to his knees, raised his hands and prayed. On the platform, the men shook hands and embraced, perhaps saying farewell and maybe in the process telling one another that if not saved by some miracle, they'd meet again in the afterlife. Just then, a potential miracle did appear. No one on the ground saw where it came from, but another rope descended, almost to the roof. A roar went up from the spectators. Maybe their prayers had been answered. But this hope also proved short-lived. The rope burned, just like the others. If only the firemen on the roof could raise a ladder. They shouted to those on the ground to send one up, but none appeared. Now, it really was too late.

The first man who leaped, feet first, fell through the wooden roof and landed in a pit of fire below. The next tumbled head-over-heels and landed head first. The third grabbed for what was left of a burning rope, like the proverbial drowning man and the straw. He, too, ended up in a swath of fire. In a frantic effort to break the falls of men to follow, those on the roof removed coats, vests and even trousers to form a cushion. They were driven back by the advancing flames. One by one, the trapped men leaped to their deaths until only Captain Fitzpatrick and another fireman were left. It appeared that Fitzpatrick tried to induce the other man to grab a remaining strand of rope and take his chances. The man balked, so the captain seized what was left of the rope and moved downward. As he let go, he sprang away from the flames that waited below. The other man attempted to follow suit, but just as he let go of the rope, the entire tower wavered, then crashed, taking the fireman down with it.

An artist's vision of trapped firemen jumping to their deaths rather than being burned alive.
Courtesy of the Fire Museum of Greater Chicago.

At ground level, firemen continue their attack on what had become a conflagration. *Courtesy of the Ken Little Collection.*

Fitzpatrick was alive but critically injured. Chief Murphy, who had retreated to the ground when the fire on the roof became too intense, witnessed the leap. Murphy recruited Captain Richard Kennedy and firefighter Hans Rehfeldt for a daring mission. With firemen spraying them with water, the two ascended a ladder and, dodging flames, rushed to the side of the fallen captain. They raised Fitzpatrick to his feet, secured a line around his upper body and slowly lowered him into the hands of those on the ground who would place him in an ambulance. The roar that went up from the crowd, the *Chicago Tribune* reported, "could be heard as far away as Englewood." But the heroism was in vain; Fitzpatrick died soon afterward at the emergency hospital of internal injuries, a compound fracture of the right leg and smoke inhalation. Murphy suffered a burned hand and sprained ankle; Kennedy had burns to his hands and face. Rehfeldt came through unharmed.

Nineteen engines answered the special alarm but were helpless against the fire. After the collapse of the tower, flames burst forth from every part of the building. Many of those who responded fought the fire with tears in their eyes. The president of the Hercules Iron Works, who came to the scene with the company manager, said, "I did order the necessary changes to be made to the smokestack [after the previous fire], but I didn't know whether it was

done or not." Didn't he know that the fire department and the underwriters had condemned the building? "No, I did not. I knew they criticized the chimney and wanted alterations, but nothing more."

Neither tragedy nor fire had finished with the World's Columbian Exposition. On October 28, two days before the scheduled closing, Mayor Carter Harrison Sr. led a formidable assemblage of public officials from around the country in a Reunion of American Cities, the last major event before the finale. After delivering a speech in which he declared, "I intend to live for half a century yet," the mayor returned to his home on the near West Side. He retired to his study for a nap but was soon awakened by his housekeeper who had admitted a young man she mistook for a political aide. The man was, in fact, a deranged job seeker who met Harrison at his study door and fired three shots at close range. The sixty-eight-year-old mayor died within minutes. Memorial services supplanted closing festivities at the fair.

On the night of July 5, 1894, with firefighters battling a wave of Pullman strike–related arson in rail yards near the stockyards, nearly all that remained of the White City went up in flames. The cause was never determined. Perhaps vagrants, cooking over an open flame, were responsible. Or maybe arsonists, bored with torching boxcars, found a new way to express themselves. Whatever the trigger—and with federal troops, police and firemen tied down by torch-wielding rioters—the spectacular fire attracted a crowd of onlookers estimated in the tens of thousands. The surviving exhibition halls had been signed over to a salvage company that had yet to begin work. Bone-tired firemen, who weren't needed at the moment to extinguish burning railroad property, could only watch along with the spectators. Flaming debris jumped from one temporary structure to the next, easily igniting the wood, cloth and plaster construction. The gold and white administration building tottered, stood still momentarily and then collapsed like an accordion. The onlookers appeared calm, almost serene, as if they were watching the exposition's final fireworks display. The only gasps came when the giant Manufacturers and Liberal Arts Building imploded toward the end of the spectacle. A World's Fair mounted to showcase Chicago's rise from the ashes of 1871 had itself been reduced to ashes.

4

SHOWERS OF SPARKS, SHEETS OF FLAME

THE NORTHWESTERN GRAIN ELEVATOR FIRE
AUGUST 5, 1897

The year 1897. Another month, another of the city's seemingly endless succession of grain-elevator fires. This outbreak claimed the lives of six Chicago firefighters and injured thirty-three, some or all of whom might have been spared had some elementary precautions been taken. The massive fire and explosion on August 5 tore apart the hulking Northwestern grain elevator on the North Branch of the Chicago River near Grand Avenue, one of the oldest elevators in the city. The fire was believed to have started on the first floor at the north end when an overheated bearing of a hoist ignited accumulated grain dust. Firemen dread fighting grain elevator fires because when the dust dries, it can be as readily ignited as gunpowder and explode with the force of a powerful bomb. Given the age of the Northwestern building, dust had been allowed to accumulate year after year, settling into cracks in the walls. With sufficient buildup, it would take only a small amount of abnormal heat to trigger a catastrophe. Fire inspectors who surveyed the scene later stated that the use of existing dust collection technology could have prevented such a buildup, greatly reduced the magnitude of the fire and held losses to $1,000 instead of the $500,000 incurred. Implicit in the inspectors' report was the suggestion that lives could have been saved as well.

Shortly after 6:00 p.m., a Northwestern employee named Ed Anderson dashed into the engine room and told engineer Walter Grubb that he smelled smoke in the elevator. Disregarding the potential danger, Grubb decided to see for himself. He found noxious smoke hanging heavily in the grain dryer

and then quickly mounted an iron spiral staircase that led to the bin floor one hundred feet above. He didn't see any flames because, at this point, they were confined to the space below the floorboards. Grubb pushed on. When he reached a landing, he began to feel heat. Moving to a spot where he could get a good overview, he saw curls of flame and smoke coming through the walls. Clambering down three steps at a time, stumbling and sliding, he got about halfway to the bottom of the staircase when he encountered the night watchman, accompanied by a fireman, on their way up. Grubb yelled at them to run for their lives because the bin floor was about to go. The three retraced their steps at full speed, Grubb pausing long enough to open the steam valves on the boiler. Winded by the time they had fled the building, they looked up to see the cupola and the entire upper section engulfed in flame.

When the first firefighters arrived, they found fire racing through grain chutes at the north end of the building and shooting from windows and through the roof. In addition to the dust, the flames found ready fuel in thousands of bushels of corn, oats and wheat. En route to the scene from quarters at Chicago and Milwaukee Avenues, fire marshal Ener Anderson of the Fifth Battalion surveyed the blazing skyline and stopped his buggy to send a 4-11 from an alarm box. (Extra alarms calling for additional firefighters and equipment begin with the code 2-11 and are increased as necessary.) He knew it would be a long night. Before it was over, nearly every available piece of equipment in the city would be needed to keep the flames from advancing beyond the elevator and attacking the entire northwest section of the city. A strong east wind was blowing away from the river and toward an area of homes and manufacturing sites.

Like an elevator on the far South Side that burned in January, the Northwestern building stood surrounded by blocks of railroad tracks that composed the Northwestern Railway's freight and passenger yards. This time, firefighters had better luck, or so it seemed for a while. They were able to bump their engines over the labyrinth of tracks, circumventing hundreds of empty and loaded freight cars as well as some three hundred empty passenger coaches. Arriving firemen were greeted by pandemonium in the form of frenzied railroad workers, barking orders and following orders, in a mad scramble to save the threatened cars. When the fire broke out, three switching crews, aided by extra freight and passenger engines, began clearing the tracks nearest the fire. Sixty loaded freight cars, standing beside the freight house, had caught fire almost immediately. With great difficulty, the switchmen coupled the blazing cars together and pulled them to an area where the flames could be extinguished away from the intense

heat and smoke generated by the burning building. Civilian bucket brigades joined the effort. The shrill whistles of locomotives mingled with horn blasts from tugboats in the river, executing their own breakneck efforts to tow away vessels moored in dangerous waters.

As commercial shipping got moved out, the fireboats *Yosemite* and *Fire Queen* moved in. Assistant fire marshal William Musham, who nearly drowned in the river at an 1894 lumber district fire, assumed command of the boats, along with the overall battle at the south end of the elevator. Musham and Chief Swenie arrived at the scene almost simultaneously. They found Anderson and his men had been able to keep the fire confined to the upper part of the building, where tongues of flame were shooting about fifty feet into the air. Swenie, with Anderson at his side, took charge. He ordered every available engine to form a line on the river side of the elevator. Within ten minutes, eleven formed a row, directing streams of water. About thirty feet from the elevator stood a low warehouse that belonged to the Jung Brewing Company. Engine Company 27, with a captain, lieutenant and six men, ran a line to the building. Other companies formed up alongside Engine Company 3. Swenie told Anderson that the possibility of a grain explosion appeared to have lessened because the roof looked as if it had burned away, permitting the release of pent-up dust. Soon afterward, the vagaries of out-of-control fires demonstrated that even veteran fire chiefs can be proved wrong. A roar from the center of the inferno signaled the feared dust explosion that tore the old elevator apart, collapsing most of the walls and showering the firemen with iron, bricks, timber and tons of grain dust that embedded the hands, faces and clothing of anyone in its path. Many of the men were buried. Some of the debris was hurled for blocks around. Only part of the north wall was left standing.

That was just the prelude. Sheets of flame retraced the path of the airborne debris, blistering firemen who might or might not have been felled by the walls or projectiles. Some were struck by masses of white-hot sheet metal torn from the sides of the building. Engine Company 3 absorbed the worst of it—pipemen John Coogan, twenty-six and engaged; Jacob Schnur, forty-five and married; and Jacob Straman, twenty-five, married and the father of one, were killed instantly. Charles Conway, driver of Engine 27, died later at Cook County Hospital. The fate of Chief Swenie's driver, Thomas Monaghan, remained uncertain. Different theories had him buried under debris, blown into the river or perhaps losing his mind and wandering off. Monaghan's body was recovered from the water about a week later, after his hat was seen floating on the surface. He was thirty-five and was to be married in a few weeks.

Chief Swenie had a close shave. Along with Marshal Anderson and every other man in the vicinity, the chief got knocked to the ground. Swenie admitted it was his closest call in a long career of fighting fires. "I thought it was all over. When the blast struck, 'This is the end,' [flashed through his mind]. To tell the truth, I never expected to get out alive. No one could breathe that air fifteen seconds without dying." After Swenie fell, he turned over and over, his mouth, nose and ears filling with cinders, his eyes with sparks. His lungs ached with every breath. His clothes on fire, the chief staggered away from the intense heat. He'd badly wrenched his left arm and right foot. Limping to the freight house, he fell into a stream of water and soaked himself thoroughly. That was when he determined that he wouldn't let this fire defeat him. Swenie resumed command and stayed on the scene until the last ember was out.

Meanwhile, determined firemen, braving a wall of flame, were rushing to help their stricken comrades. Engine companies redirected their hoses from the building to spray the rescuers. Seven of the eight men of Engine Company 27, who had positioned themselves atop the brewery warehouse next door to the elevator, had been knocked down by the explosion. Some lay stunned. Fireman Conway, the driver, had moved nearer to the elevator and was fatally injured under a pile of red-hot bricks. The others owed their lives to fireman Daniel Flynn and police officer Denis Braser of the West Chicago Avenue Station. The fire was moving ever closer to the brewer's property. With flames licking their clothing and blistering their hands and faces, Flynn and Braser climbed a ladder they'd placed against the brewery building and began lowering the men, who were put in ambulances and taken to hospitals for treatment of burns and cuts. Eventually, every available police ambulance and wagon in the city was dispatched to the scene. Among the injured were assistant fire marshal John Campion, who was treated for facial burns, and Captain Martin Lacey of Engine Company 11, who suffered serious cuts to his hands and arms. No stranger to historic fires, Lacey would undergo an even more shattering experience thirteen years later when he narrowly escaped death at the Nelson Morris stockyards fire. Four years earlier, he'd been present at the World's Fair cold storage building fire. Another of the injured, assistant fire marshal William Musham, said, "[All] of a sudden there came a blinding flash and roar, and then I remember finding myself on the ground with mighty little breath in me. I could hear several men about me groaning and calling for help...One poor fellow just behind me called out for me to help him. I called to two men [to help him]. I think he must have had his legs broken." Musham's nose had been broken by a falling brick to go with the facial burns he'd suffered.

Chief Swenie's handling of the fire came under attack by one Chicago newspaper. He responded by saying, in effect, that criticism comes with the territory but failed to see how he could have acted with better judgment. "After all is done and said, firemen are employed to fight fires and not to stand and look at them." With the roof almost gone, he said, he figured that if there were to be an explosion "the force would find a vent through the weakest part, in this case through the roof…There was no fireman within sixty feet of the elevator when the walls fell. I was there myself and if I had supposed there was any danger, do you think I would have permitted my men or myself to be within reach?" (Fast-forward to 1910. Fire Marshal Horan and assistant marshal William Burroughs didn't survive the Nelson Morris fire to answer a similar rhetorical question. The twenty-one men killed, including Horan and Burroughs, were standing immediately next to the wall that fell on them.) "Fighting fire," Swenie continued, "is a hazardous occupation at the best, and when men join the department, they have thought this all over…this effort is always accompanied by more or less danger. The wisest general that ever lived cannot always accomplish results without some loss."

As in so many cases before and after, fire supplied a postscript to the Northwestern elevator disaster. The following night, a dust explosion at the E.A. Hartwell Company's planing mill, on Des Plaines Avenue and Fulton Street, reinjured four firemen recovering from burns suffered at the Northwestern fire. The mill was located about three blocks south of the elevator. Assistant Chief Campion was among the four injured. All suffered burns to their faces and some to their necks and hands. No one was seriously injured. The force of the blast, which blew the cupola off the roof of the Hartwell facility, lit up the neighborhood and startled residents for blocks around. Members of Truck Company 3 and Engine Company 17 came perilously close to being thrown from the roof of the five-story mill. The explosion occurred while firemen, led by Campion, had just made their way through a narrow hatchway trying to locate the fire. They were tugging at a small door that led to the cupola when the air rushing in ignited dust that had been smoldering for some time. Shavings, smoke, fire and hot coals, followed by a blast of scorching air, shot through the door into the faces of the firefighters. Then, like an erupting volcano, the top of the cupola blew, shooting smoke one hundred feet into the air. But the explosion marked the end, not the beginning. Almost immediately, the fire seemed to die down. Campion and the three others, their faces blackened and eyebrows and other facial hair singed, began groping their way back down. Sensing that the danger had passed, the marshal quipped, "That's twice this week I've been blown up."

WARNINGS IGNORED

PORTENTS OF THE IROQUOIS THEATRE FIRE
DECEMBER 11, 1900; JANUARY 12, 1901;
AND DECEMBER 30, 1903

At the turn of the century, the dirty work of the Fates could have been foiled and unimaginable grief avoided if the city government had heeded the lessons taught by two relatively minor, but unusual, incidents. Weirdly enough, the fire department was not directly involved in the incidents because there were no flames, only two other factors that often lead to fire-related deaths: city code violations and panic.

Two weeks before Christmas in the late afternoon of Tuesday, December 11, 1900, an audience of about one thousand people, most of them children, was being entertained at the Twelfth Street Turner Hall on the near West Side. Included in the entertainment was a Punch and Judy show, and prizes were to be distributed to the youngsters. The turnout was large because the event had been widely advertised in the area, and admission was only five cents.

The children were crowded into the hall on the second floor of the three-story frame building on the corner of what are now Roosevelt Road and Union Avenue. The large structure had been built in 1872 in an area spared by the Great Fire a year earlier. Over the ensuing years, the hall had been the scene of many political meetings and other events. Stores and a saloon occupied the first floor. A corporation owned the building, and a man named Gustav Yoose served as proprietor of the hall and saloon.

In addition to the large seating area on the second floor, a gallery filled the rear of the hall. The gallery, which could hold at least 150, had only one exit—a narrow stairway that ran down to the hall. In the main seating area,

two exits with short, winding staircases, funneled into the single eight-foot-wide stairway leading down to the main entrance.

There reportedly was another small exit behind the stage. If so, most members of the audience probably were unaware of it, so in the event of an emergency, almost every occupant of the hall and gallery would be forced to converge on one stairway. If fire blocked that stairway, there would be no way out. In addition to a lack of sufficient exits and fire escapes, other code violations prevailed, including doors that opened inward, not outward. In other words, the large frame building was a firetrap.

Everything appeared to be going well when the time came for the excited children to receive their prizes. Suddenly, a loud crash from the stage was heard. Glass had fallen from an electric light reflector suspended from above. With the crash came the voice of an unidentified youngster, inexplicably hollering, "Fire! Fire!" Other children took up the shout, and the audience sprang to its feet and started for the exits in panic, even though there was no fire. Chairs got knocked over in the mad rush, and smaller children were knocked down and trampled by their bigger and stronger counterparts. The gallery's narrow stairway quickly became jammed. Having no place else to go, children began jumping over the railing, landing on others below.

A major jam-up occurred at the two exits leading to the winding stairs as children came running from all directions. At the juncture of the winding stairs, the situation appeared hopeless. Children began falling down and getting trampled. Four police patrol wagons raced to the scene to transport the more seriously injured to hospitals and the less seriously to their homes. Other minor injuries were treated at a nearby drugstore. Amazingly, there were no fatalities, and only eighteen people were reported injured, sixteen of them children. Additional injuries might have gone unreported because many youngsters headed home after escaping the building. Among the more seriously injured was a seven-year-old girl who was thrown underneath the crowd on the main stairway and suffered a broken right arm, a broken collarbone and cuts on her head and face. A twelve-year-old girl who jumped from the gallery injured both ankles.

Because there was no fire and everything happened so quickly, the fire department apparently wasn't called. Police captain John Wheeler reported later that he personally had notified the building department that the hall was a firetrap but saw no evidence that his complaint was acted on. The building department apparently wasn't fazed by what could have been a major tragedy because the hall remained open for business. It took only a

month for the department's inaction to show serious consequences—déjà vu on a grander scale.

It happened on Saturday, January 12, 1901, and once again it was late afternoon. The hall and gallery were crowded with women and children there to see a drama company's production of a play in Yiddish called *The Greenhorn*. The play was in its final act, and it was almost time for an eagerly awaited drawing. Each child had been given a raffle ticket, and the winners each were to receive a doll. Hundreds of youngsters were present without a parent or guardian.

The fun ended suddenly when a boy noticed a puff of smoke coming from a heating register at the rear of the hall. He shouted, "Fire!" According to the *Chicago Tribune*, "The peaceable audience was converted into a struggling, hysterical mass. There was no fire at all, only a little smoke being blown out of the register by the wind."

Performers on stage pleaded with the audience to remain calm but to no avail. One said she would never forget the awful scene of panic.

> *Thinking I might yet divert the attention of the audience, I tried to go on with my lines as if nothing had happened. For an instant I thought the ruse successful, and an interval passed that seemed an hour to me. I was closely watching the audience out of the corner of my eye, and then to my horror I saw the entire gathering rise as one person and turn terror-stricken, towards the one exit.*

The narrow stairway leading from the gallery quickly became jammed. Hysterical women who found no other means of escape dropped their crying children onto the heads of people below on the main floor, where the crazed audience was stampeding toward the two exits. If someone made it to an exit, the person found a mass of humanity preventing access to the winding staircase. Farther on, the main stairway itself was jammed with screaming people. Those who fell down on the landing or stairs were trampled immediately. The stairway began creaking from the weight of the crowd, and police, fearing it would collapse, pulled down the banisters, causing some fifty women and children to spill over and fall the remaining distance to the first floor. The unusual maneuver probably prevented a collapse. A few people found a window and jumped to the concrete below. It resembled the scene two weeks before Christmas but was much worse.

When it was over, injured people could be found on the main floor, in the gallery and on the stairways. Scores of "walking wounded" wandered the

streets outside, seeking assistance. This time, there were five fatalities: seven-year-old Anna Goldberg fell from the gallery and was trampled by the crowd on the main floor. She died on the way to Cook County Hospital. Rebecca Libsky, fifteen, was trampled and also died on the way to the hospital. Five-year-old Regina Mellenbach was crushed and trampled while being carried from the hall and died at a nearby drugstore. Thirty-seven-year-old Mrs. Anna Solomon was crushed in the stampede and died at the hospital. Birdie Zeidman, eleven, who was trampled and described as "hardly recognizable," died on the way to the hospital.

Many of the injured were treated at the drugstore at Twelfth and Halsted Streets, which had also become an emergency first aid center during the pre-Christmas panic. Other injured were transported home or just walked there. Some were reported in the newspaper as having "internal injuries." The total number hurt was placed at fifty or more.

Proprietor Gustave Yoose said he was in the saloon on the first floor while quickly pointing out that the bartender was not there.

> *No one was drinking. Suddenly, I heard a cry and presently the rumble of rushing feet. The sound developed into a roar as the mob, screaming and shouting, swept down the side stairs into the main flight. [In] a moment the struggling mass stopped and then, as a policeman tore away the banisters, the crowd flowed out onto the floor and into my saloon.*
>
> *It was all the fault of the boy who yelled fire. The building is quite safe, and has never been condemned by the building department.*

Once again, the fire department was not involved.

Despite the serious problems exposed by the two panics, former building commissioner James McAndrews, who had retired only a few days earlier, appeared to deny the obvious: "I don't know of anything the building department could have done to add to the safety of the patrons of the hall…The stairway is broad, and the entrance leading to the interior of the hall is sufficiently large to enable a large crowd to enter or emerge in safety. I consider the building safe."

The department's chief building inspector, William Barry, said he had read of the first incident in the newspaper, but it was not policy to investigate halls unless a complaint was received, which, according to Barry, had not happened. What became of Captain Wheeler's complaint was anyone's guess.

A *Chicago Tribune* editorial placed blame: "The course of our municipal life is that all ordinances, even the most important, are continually being

suspended for political reasons. The building ordinance was not enforced in the Turner Hall case because it did not seem politically expedient to do so."

After an inquest, a coroner's jury placed no blame for the tragedy on the building department. The jury did recommend that an ordinance be enacted to require that all chairs and tables in amusement halls be fastened securely to the floor. The jury said it believed such an ordinance would have prevented the five deaths.

The inquest did produce one significant revelation: a stagehand testified that there was indeed an exit behind the stage, but it was nailed shut. Meanwhile, new building commissioner Peter Kiolbassa said one of his first duties would be to close down the Twelfth Street Turner Hall.

Police averted another panic at the old hall on March 27, 1903. The hall was reopening as a playhouse known as the Star. Its first performance was a Jewish drama titled *Gabriel*, and nearly one thousand people turned out. A police captain and six officers were present because the owner had been warned that an attempt would be made to prevent the opening. When a small fire broke out in some bunting draped from the gallery, there were shouts of "Fire!" and it appeared another panic might ensue. But police stepped in and, according to the *Chicago Tribune*, "the policemen were forced to strike

Because of the huge number of fatalities at the Iroquois Theater, fire department hose wagons were pressed into service to remove bodies to the morgue. *Courtesy of the John McIntyre Collection.*

several of the leaders to hold back the crowd, but in a few moments the panic had subsided." The fire was believed to be accidental. It was quickly extinguished, and the performance continued.

The incidents at the Twelfth Street Turner Hall were merely the preliminaries. The Iroquois Theatre Fire of December 30, 1903, sent shock waves around the world. Its 602 victims, mostly women and children, represented the greatest loss of life by fire in the city's history, far exceeding the toll from the Great Fire of 1871. Nothing approaching an exact count for 1871 was ever reached. Best estimates placed the number at 200 to 300. What made the Iroquois disaster even more tragic was the fact that the fire and its compounding hazards were easily avoidable, as were the preceding incidents on the West Side.

6

VOLCANOES ON THE RIVER

THE BURLINGTON GRAIN ELEVATOR FIRE
AUGUST 3, 1908

I t was the hottest and hardest fire to fight that I have seen in years. For more than two hours, I was in dread of a conflagration that would sweep all over the city." So spoke chief fire marshal James Horan about the Great Elevator Fire of 1908, one of the worst in Chicago's history. Horan said it was a miracle no one was killed or injured. (One fireman did suffer a non–life threatening injury.) The same conditions that had preceded the catastrophic fires of 1871 and 1874 prevailed on August 3—a long dry season, a stiff southwest wind and highly flammable structures.

The fire started in a large Burlington Railway freight house near Sixteenth and Canal Streets along the west bank of the Chicago River. The building stood between two slips that extended east, meeting the South Branch, and was surrounded by three operating grain elevators, another under demolition, two warehouses, oil refineries and railroad yards. Two big freighters had just unloaded their contents at the Burlington facility, filling it to near capacity. Someone in the warehouse supposedly tossed a lighted cigarette into a store of chemicals, including nitroglycerine that was destined for a gunpowder factory. Thus, the drama began.

Several loud explosions preceded the outbreak of flames. The frequency and volume of the blasts increased as the freight house became engulfed across its entire width. Immediately north of the flaming building loomed Elevator E, owned jointly by the Burlington Company and Armour and Company, and a little farther north, across one of the slips, rose its sister, Elevator F. The two elevators, each topped by two-hundred-foot-high cupolas,

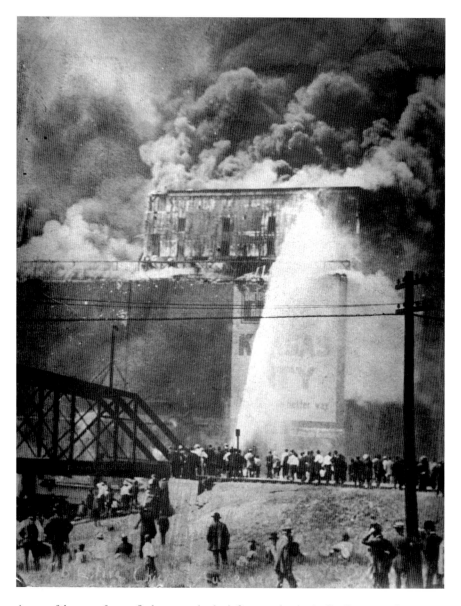

A powerful stream from a fireboat attacks the inferno raging in the Burlington grain elevator. It was another conflagration that threatened to destroy much of Chicago. *Courtesy of the Ken Little Collection.*

contained a total 200,000 bushels of wheat and 100,000 bushels of corn. They didn't stand a chance against the southwest wind that quickly carried the fire to their doorsteps and whipped them into twin towers of smoke

and flame. South of the freight house, just beyond the other slip, lay a third Armour elevator filled with nearly 1 million bushels of grain. This building adjoined a large Carson Pirie Scott warehouse, while still farther south, on both sides of the river, was a cluster of Standard Oil refineries. Also in that direction lay a highly flammable structure owned by N.K. Fairbanks and Company. Determined efforts by the crews of the fireboats *Denis J. Swenie*, *Illinois* and *Chicago* prevented the flames from spreading south, attacking these properties and opening up an ominous pathway to another Great Fire. The fireboats' success proved especially critical because land-based firefighters were already facing almost insurmountable odds. Elevators E and F were spewing blazing timbers and glowing ash that were causing other fires to erupt half a mile away. The Burlington rail yards, a half mile long and a quarter mile wide, extended north of the elevators and were crammed with freight and passenger cars. Those that weren't hit by flying brands seemed to burst into flame from spontaneous combustion. Eventually, rail yards from Sixteenth to Twelfth Streets were ablaze. Approximately one hundred loaded freight cars and two passenger coaches were destroyed.

The first alarm was sounded about one o'clock on a Monday afternoon. Given the fire's ultra-threatening location, Horan headed to the scene on the double. The chief and other senior officers were all too familiar with the terrible conditions that would confront firefighters. "The owners knew of [these conditions] and we knew of [them]," Horan remarked later. "I do not believe there is another place so bad in the city, no hydrants and no facilities for getting the engines to the scene of the fire. Chief Campion warned them of the dangers four years ago." For Horan to put the Sixteenth and Canal Streets location ahead of the stockyards on his "grouch" list was saying quite a lot. He was appalled by the apparent indifference of the industrialists, whose multimillion-dollar investments they now were called on to save or salvage at the risk of their lives. Firemen located the nearest hydrant nearly half a mile from the fire. In some places, hoses stretched for a mile. "We had to build plank roads across the [rail] yards to the river before we could do a thing," the chief noted bitterly. "The roads were hastily built, and often they broke down, dropping the engines between the tracks. You can imagine what a fine time we had in that furnace, making three horses drag a five-ton engine over railroad tracks.

"When we got to the river, we were on the leeward side of the fire and the heat was intense. We had no [drinking] water, and we were half a mile from our coal supply. Men walked that half a mile carrying in their arms the

Firemen use their helmets to deflect intense heat as they battle the Burlington elevator conflagration. *Courtesy of the Ken Little Collection.*

coal to keep the engines going, and that through country so hot that it was a wonder the coal didn't burn as they held it."

Firemen couldn't get within two hundred feet of the inferno. The heat felled entire companies that tried to approach. Some pulled hose by crawling on their stomachs, like infantrymen in combat, while fellow firemen sprayed them with water to keep their clothes from catching fire. Ten horses dropped in their tracks, as if struck by lightning, but recovered afterward.

When the lofty cupolas and large sections of upper walls of Elevators E and F came crashing down, flames shot two hundred feet into the air and twice leaped the river, setting fire to docks on the east bank. The flames soared over the heads of firefighters who had moved eighteen engines into place along the river back to the north of the main fire. These engines, along with six others at the end of the slip, were drawing water from the river. By this time, sixty engines were engaged in the fight. Half a mile to the north, cinders and flaming brands were setting fire to the Rock Island's Elevator A, as well as the Wabash and Erie freight houses. Continuous streams of water saved these structures from total destruction and prevented the spread of fire to adjacent buildings.

The always-fickle wind shifted from the southwest to due west about an hour after the fire started. The change provided a welcome break to firemen and railroad employees who were winning their battle to control the fires at the north end of the yards. That good fortune, however, came with a significantly greater downside: the west wind now threatened the South Loop with burning debris and cinders that traveled as far east as South Wabash and Michigan Avenues. More than one hundred small fires sprang up that were mostly restricted to rooftops and awnings. The only serious blaze in that district hit the American Refrigerating and Transit Company building at Fourteenth Street near State Street. The loss totaled about $3,000.

Into the early morning hours of Tuesday, August 4, the fireboat *Illinois* continued its defense against any southward spread from its position in the slip between Elevators E and F. Not much of Elevator E was left standing, but enough of a brick wall remained to be blown outward by a terrific explosion caused by the generation of gas in the heated grain. Heavy debris from the wall fell on the bow of the *Illinois*. Ropes tying the boat to the dock kept it above water for more than a minute—long enough to enable the crew's flight to safety before the $200,000 *Illinois*, pride of the floating department, sank in twenty feet of water. The *Illinois* was raised three weeks later and put back in service at the nominal cost of $1,000.

The sinking of the *Illinois* illustrated the risks associated with fighting fires from the water. But the fireboat's performance, along with that of its sister vessels, underscored their value. In this instance, they could claim a large share of the credit for stopping the fire from spreading south. "If the flames had got to the south," Horan declared, "we would have had another Great Chicago Fire. Or if the numerous fires that started across the river had not been so promptly extinguished, it's hard to say what the outcome would have been. It is safe to say that for two hours…Chicago was at the mercy of the wind and fire."

Chicago had its share of major grain elevator fires. Nine workers were killed on May 11, 1939, in an explosion and fire at the Rosenbaum and Norris elevators at 102nd Street and the Calumet River. Twenty-two people were injured, including eighteen firemen. Father William Gorman, fire department chaplain, leads the way as a fireman is carried off for medical care. It was a 3-11 alarm with six special calls. *Courtesy of the Ken Little Collection.*

Furniture store fires in Chicago tended to be spectacular. Four employees and two customers were killed on December 29, 1952, in an explosion and fire at the General Furniture store at Sixty-second and Halsted Streets. Although a firehouse was little more than a block away, firemen found the building almost totally engulfed in flames. *Courtesy of the Ken Little Collection*.

STEEP PRICE FOR NEGLIGENCE

THE L. FISH FURNITURE FIRE
MARCH 25, 1910

On a sunny morning in the early spring of 1910, eight young women and four men died in yet another fire that never should have taken any lives, let alone a dozen. Immediately, accusations of negligence and irresponsibility, followed by cries of "Not my department!" rose to a level reminiscent of those that followed the Iroquois Theatre and Temporary Crib Fires. This time, the chief fire marshal, Big Jim Horan, and his men would draw withering criticism unprecedented during the chief's twenty-nine years with the fire department.

Employees in the sixth-floor offices of the L. Fish Furniture store at 1906–08 Wabash Avenue were in a particularly good mood on March 25 as they settled in for the start of the workday. Winter was showing signs of ending. Bright sunlight streamed through the front windows, bathing the long rows of desks and typewriter tables where the women sat chatting, away from the inner office of Simon Fish and his secretary. A small squad of office boys sat outside Fish's door. One of the young men, twenty-one-year-old Leo Stoeckel, received a somewhat unusual assignment from Harry Mitchell, company auditor and Fish's brother-in-law. Mitchell liked to smoke while he drove his car and told Stoeckel to go down to the fourth-floor finishing room and fill three cigar lighters with benzene. Stoeckel said he used a five-gallon can to fill two of the lighters and was working on the third when a sheet of flame "almost blinded" him. The young man thought he might have accidentally pressed the ignition button on the lighter, setting fire to some of the benzene that had spilled on

his hand. "The flames shot up in front of me, and I either dropped the can or it blew out of my hand," along with the burning lighter, which ignited the oil and caused an explosion. Flames shot toward the ceiling, filling the room in an instant. Reeling and terrified, Stoeckel rushed for the stairway and reached the alley in a daze. He said he didn't warn anyone on the way down because he "didn't think there was any danger."

It remained for John Schmidt, an employee on the fourth floor, to phone in the first alarm shortly before 8:30 a.m. Many more alarms followed as the fierce, rapidly spreading flames feasted on varnish, benzene and wood alcohol in the repair department. About seventy-five employees were at work throughout the building, which hadn't yet opened for customers.

Harry Mitchell, whose seemingly innocuous instructions to Stoeckel set events in motion, paid with his life trying to perform a heroic deed. Mitchell had gone down to the first floor just before the flames attacked. His voice could be heard shouting, "Those girls upstairs must be saved!" He got into an elevator and told the operator to hurry to the sixth, or top, floor so he could take personal charge of an evacuation. Mitchell never made it back down. His brother-in-law, Sigmund Fish, succeeded in a valiant rescue attempt but not before surviving a close call. About the time the first alarm was turned in, Sigmund was taking an elevator from the third to the fourth floor. Fish and the elevator operator, William Carter, heard a click. A thermostat controlling the doors, activated by the heat, caused them to slam shut. Fish and Carter were imprisoned. Fish tried but failed to open the jammed doors. In a frenzy, he discovered some superhuman strength and was able to tear one of the sliding doors from its fastenings, burst open a fire door and run through the third floor shouting an alarm.

Employees on the three lower floors escaped safely to the street. Flames had cut off escape from the fourth and sixth floors. Elevator operator Carter, who had stayed with the car when Fish dashed off, tried to run it up to six in hopes of rescuing the women who worked there. Before he got very far, the elevator struck a heavy iron emergency door that had clamped down on the elevator shaft when the fire started. Carter realized his effort was useless and descended.

Only two employees got off the sixth floor alive. The floor came equipped with just one rickety fire escape, but even that proved nearly useless because steel lockers had been stacked across the back of the room, making access virtually impossible. Quick thinking saved the life of salesman M.B. Zeiner, who remembered a freight elevator at the rear of the building and opted for that recourse rather than joining a rush to the front of the building.

Zeiner broke open the door and saw the top of the elevator far down the shaft. He jumped to the center cable and slid down two floors to where the car was resting. Climbing inside, he managed to ride the rest of the way down. Zeiner said he couldn't understand how others on the floor missed seeing five rear windows that overlooked a roof next door, only a few feet below. "Still, I never thought of it myself but took the nearest way, taking a chance on a broken neck. Just before I leaped," Zeiner related, "I called to the others, but they all kept on to the front, and I supposed they had found another exit, probably the firemen's ladders. I remember seeing Mr. Mitchell somewhere, but where it was I don't know for I was filled with smoke and almost everything now is a blank."

Seventeen-year-old office boy Julius Jeschke did find the rear windows. When he heard one of the young women on the sixth floor shout, "Fire!" and he saw smoke and flames going past the front windows, he headed toward the back. "The girls were up in front screaming and hanging onto each other when I started back…I broke out one of the windows where I saw a fire escape and crawled out on that and climbed down." Jeschke jumped the remaining one story into the alley, landing on his back and losing consciousness. Onlookers carried him to a store nearby. "All the girls lost their heads," he said later, "for they were screaming fierce when I started back to the rear. I didn't see what happened to them."

Throngs that had gathered on Wabash Avenue saw what happened to one of the women and got a gut-wrenching preview of what would befall the others. Through the smoke, the spectators could see the terrified faces of the doomed women on the sixth floor and hear their faint cries, "Save us, save us!" As if on cue, the first fire companies began arriving, like the cavalry. In a more just world, the firemen would have raised their ladders and carried down the women, just in the nick of time. Instead, the men with their equipment were forced to push their way through "a howling mob," in the words of third assistant fire marshal Thomas O'Connor, the first senior officer on the scene. Chief Horan and assistant chief Charles Seyferlich arrived minutes later, after the fire had gone to a 4-11. By now, the elevated tracks at the rear of the building were aflame.

One man's howling mob can become another's rescue party. Watching the flames destroy his furniture store, Simon Fish bitterly criticized the arriving firemen. Standing in the street, fists clenched, the company president accused the men of arriving late and then interfering with employees attempting a rescue effort. After their late arrival, Fish charged, the firemen were slow to raise their ladders, further imperiling the trapped women. "When some of our

employees started to raise [ladders] from the tops of adjoining buildings, the firemen drove them away. It was an outrage."

"It's true that we drove a mob of men away from ladders," battalion chief Thomas O'Connor responded. "They didn't know what they were doing all up in the air. They were interfering with our work. They say we should have directed our attention to the south side of the building. This is untrue. There were women up in the front windows of the sixth floor, and it was our duty to give them first aid."

Chief Horan backed his deputy, saying he would have done the same thing. "We are not taking orders from outsiders, especially people so excited that they don't know what they're doing." O'Connor noted that the "crazy mob" was shouting at firemen to get some men off adjoining roofs. "The men on the roofs were a whole lot safer than the girls in the building," he asserted.

The department's high command did agree that they encountered three serious impediments. A 4-11 fire at Twenty-fourth and Wallace Streets had tied up half the equipment that could have responded to the Fish Furniture fire. An inaccurate telephone alarm, locating the fire at the Fish store at Nineteenth and State Streets instead of the one at Nineteenth Street and Wabash Avenue, diverted the initial response by one block. Finally, and most critically, firemen trying to run ladders against the front of the building found their way blocked by a series of guy wires that supported a large company sign. Also standing in the way was a large awning that covered the front entrance. At this point, the upper floors were a mass of flames.

The faces in the windows on the sixth floor had disappeared in a swirl of flame and smoke, but one young woman, eighteen-year-old Ethel Lichtenstein, had made her way, screaming, to an outer window ledge. Blocked by the support cables and canopy, firemen placed a ladder at the southeast corner of the building and tried to move it northward but couldn't get it close enough to save Ethel or anyone else on the sixth floor. Next, they mounted a ladder on top of the canopy, but it came up about fifteen feet short of its goal. Ethel continued to cling to the building as tongues of fire lapped ever closer. Some witnesses said she'd been on the ledge for ten minutes, others claimed as long as twenty-five minutes, before she could no longer hold out. She plunged through fire and smoke, onto the awning, which was braced by metal ribs. She lay there until Dr. William Ivanhoe Kinsley ran up the stairway to the second floor, crawled through a window and picked her up. With the help of firemen who'd been on the canopy, the doctor lowered Ethel to a patrol wagon. She died of burns and internal injuries shortly after arrival at St. Luke's Hospital on the near South Side. Her co-workers

on the sixth floor were found later, kneeling in a circle, as if in prayer. They were burned so badly that they had to be identified by dental records and personal effects. Too late to save Ethel Lichtenstein or the others, firemen eventually cut away the support cables and placed ladders against the front of the building. "If it had not been for these wires," O'Connor lamented, "we might have been able to save the woman."

The fire, which destroyed the building and all the furniture inside, was declared struck out at 11:00 a.m., some two and a half hours after it started. Young Leo Stoeckel, whose mishap with the cigar lighter started the tragedy, was not charged with a crime, as originally contemplated by authorities. Stoeckel was said to be heartbroken. Recriminations continued long after the last ember had burned out. Cries of negligence by the Fish brothers stung the chief fire marshal. Until now, Big Jim Horan had won almost nothing but plaudits for his performance at countless fires during his long career. Winner of five honorable mentions for saving lives, the modest Horan preferred to joke about his only reprimand—a technical infraction incurred as a young firefighter for misjudging the length of a hose line.

A 1907 *Chicago Tribune* profile described Horan as "one of the most loyal Chicagoans. A word against Chicago to him is almost as great an offense as a criticism of the department." That was an observation the Fish brothers learned firsthand. Simon Fish threatened to bring unspecified charges against the first firemen who arrived at the store fire. "Had they responded promptly and had they been less slow in raising their ladders," Fish maintained, "I am convinced there would have been no loss of life."

Horan tossed the ball back to the company chieftain. "If the Fish people were as particular about their building as the firemen were about getting to the scene of this fire and making every effort to save persons in danger the fatalities…would not have occurred in all probability." Horan declared that the stairways were made of light wood and other flammable material; that there was only one old-fashioned fire escape that barely complied with city ordinances; and that the women on the fifth and sixth floors had little chance to escape in case of fire. "It is an easy matter for people to talk about what the firemen of Chicago ought to do," the chief concluded.

The city building department also incurred the wrath of the chief fire marshal. Horan pointed out that seven months earlier, his department notified building commissioner Murdoch Campbell, in writing, that a fire escape was required in front of the building. Horan charged that the building department's failure to enforce the notice resulted in the deaths of the fire victims. Commissioner Campbell denied that his department received such

a report, a claim that became increasingly difficult to defend as the post-fire investigation moved forward.

Regardless of how enforcement was or wasn't carried out, who held ultimate responsibility for fire protection—Fish, the lessee or the building owner, about whom little was written? The *Chicago Inter-Ocean*, which billed itself as "The Only Republican Newspaper in Chicago," believed that inquiring readers deserved to know who owned the "fire trap" it described under its March 26, 1910 headline. Readers didn't have to scan far down to learn that the owners were Joseph Medill McCormick and Joseph Medill Patterson, principals of that other "Republican" newspaper, the *Chicago Tribune*. According to the terms of the lease, Fish assumed responsibility for fire protection. However, the *Inter-Ocean*, citing Illinois law, said owners and lessees were jointly responsible. No matter how a lease reads, the paper asserted, neither owner nor tenant can shirk responsibility for making a building safe for human life.

The coroner's jury that investigated the L. Fish fire leveled a double-barreled blast at the furniture company and the city council, with more buckshot hitting the former. "We find the L. Fish Furniture Company censurable for negligence, carelessness and lack of foresight in not better providing for safety of employees," the panel concluded. The jury recommended that testimony at the inquest be turned over to the state's attorney's office for presentation to a grand jury. Had the council adopted the 1908 recommendation to increase the number of building inspectors, the jury found, the furniture store "would have been better inspected and safeguarded against loss of life."

In addition, the jury concluded that:

*The sixth floor office where all twelve of those killed were employed had recently undergone significant remodeling without a construction permit from the building department.

*Employees were given no fire drills or instructions about how to handle an emergency.

*No lives would have been lost had there been a front fire escape or inside east stairway from the sixth floor down.

*The placement of fire ladders was delayed, but only because of the obstruction presented by the cables supporting the store's electric sign.

*Office boy Leo Stoeckel, whose mishap with the lighter started the fire, was blameless.

The ink had barely dried on the jury's report when a new wave of religion swept over the building department. Commissioner Campbell declared war

on Chicago's firetraps, ordering that every building, large or small, in a two-by four-square-mile area of the central city receive a thorough inspection. The commissioner demanded daily reports, and building owners were told to remedy whatever defects were found. Campbell estimated that the task would take ten men one year to complete. "We will have no more Fish fires with attendant loss of lives of girls trapped where they cannot escape, if I can help it," the commissioner vowed.

8

THE MAN IN K-28

The Auditorium Theatre Bomb
November 16, 1917

T he United States declaration of war against Germany in April 1917
intensified fear, suspicion and even revulsion of most things German. Ill
will had been building for some time, as a result of pro-British, anti-German
propaganda and the sinking of the *Lusitania*, to name just two causalities.
Persons with German surnames, even United States citizens, were suspected
by some of harboring sympathies toward the enemy. Spies and saboteurs
were believed to lurk everywhere. "Huns" and "Teutons" became pejorative
shorthand for newspaper headline writers. Classical orchestras stopped
performing works by German composers. Hamburgers got renamed liberty
sandwiches. On November 19, 1917, President Woodrow Wilson issued a
sweeping proclamation that sharply restricted the movements of non-citizen
Germans. "Alien enemies" were required to register with the attorney general
and obtain identification cards. Among other restrictions, such people were
prohibited from setting foot within one hundred yards of waterfronts, docks,
railroad terminals or storehouses. They were barred from entering or living
in the District of Columbia. Additionally, "an alien enemy shall not change
his place of abode or occupation or otherwise travel or move from place to
place" without complying with any regulations the attorney general might
impose. German aliens were further forbidden to fly in "airplanes, balloons
or airships" or enter the Panama Canal Zone.

This tenor of the times affected the way the press covered fires, at least
in Chicago. A fire or explosion at a manufacturing site, warehouse, grain

The landmark Auditorium Building, which housed the crowded theater where an explosive device was almost detonated. *Courtesy of the William R. Host Collection.*

elevator or the like whose cause wasn't obvious cast suspicion on "alien plotters" or "enemy agents." (The word "German" was almost never used.) Occasionally, such shadowy miscreants might be found in unlikely places. A fire at a stockyards hay barn "gave rise to the theory of an enemy plot," according to one account, and prompted a federal investigation. Sometimes, police or fire authorities raised the possibility; on other occasions, reporters looking for a way to punch up a story injected their own speculation. Either way, the potential sabotage slant became standard fare. An incident at Chicago's classic Auditorium Theatre, three days before President Wilson's proclamation, contained all the ingredients.

Some 2,200 operagoers had settled into their seats at the Adler and Sullivan landmark on Michigan Avenue at Congress Street. They'd come to hear the Chicago premiere of the soon-to-be-forgotten work *Dinorah*. Galli-Curci, the soprano singing the title role, was about to emerge from the wings to sing the final passages of the first act when there was a commotion near one of the center aisles. A puff of white, acrid-smelling smoke was rising

from the middle of the floor. One woman screamed and then another. A man shouted. A tongue of flame shot six feet into the air as the smoke turned thick and green. Fumes spread through the hall and out into the corridors. The conductor, Cleofonte Campanini, signaled the orchestra to stop playing and the two singers on stage to stop singing. He directed the musicians to rise and commanded, "'The Star-Spangled Banner,' quick!" Then he motioned to Galli-Curoi to return to center stage. "Sing, madam," Campanini urged, and the soprano took up the national anthem. Not once did the conductor turn his back on the orchestra. In the meantime, seven or eight men were stamping out the last of the flames that were burning the carpet. About one-third of an audience initially on the verge of panic and rushing for the exits stopped and then joined everyone in the hall in singing the anthem. Equally reassuring to the crowd was the presence of battalion chief Michael Corrigan, who was assigned to the performance. Positioned near the rear of the hall, Corrigan rushed down an aisle as he removed his coat. At this point, accounts differ. Some say detective sergeant Edward Eisenberg picked up a sizzling piece of gas pipe and handed it to Corrigan, burning his hands in the process. Other versions have the fire officer acting alone. Not in dispute is the fact that Corrigan wrapped the pipe in his coat and hustled it out of the theater.

If the explosive device had been detonated in the theater, there could have been deaths and numerous injuries. *Courtesy of the William R. Host Collection.*

"By the time I got to the thing, it had stopped smoking," Corrigan explained. "I picked it up. It was hot. I ran to the [Congress Street] door and pitched it on the sidewalk and then ran back to control the audience which I feared was in a panic." Corrigan shouted that there was no danger, but his words might have been unnecessary. When Galli-Curci and the audience finished singing the anthem, the crowd stood to cheer her and the conductor. Campanini raised his baton, and the performance of *Dinorah* resumed at the point where it had been

Then battalion chief Michael Corrigan was considered a hero for removing the explosive device from the theater. Later in his career, Corrigan would be chief fire marshal and Chicago's fire commissioner. *Courtesy of the Ken Little Collection.*

interrupted five minutes earlier. Corrigan didn't stick around to take a bow; he was already on his way to confer with federal authorities.

Agents of the Federal Department of Investigation (forerunner of the FBI) responded at once. "We got hold of the pipe length and took it to the fire station," Corrigan related. "We could find no [blasting] caps about nor could we learn that anyone had heard any detonation. The first thing [anyone] noticed was the smoke and the sulfurous odor."

The only advance warning came when Mrs. George Hixon of North Lake Shore Drive was taking her seat. She said that when she sat down, her heel clicked against some metallic object, but she didn't look to see what it was. After the fuse ignited, the flame singed part of her shoe.

Federal and Chicago investigators pursued a number of theories. Curiously, the work of "enemy plotters" ranked near the bottom. Times were different; investigators doubted that enemies would target a civilian audience. A crank seemed a more likely suspect, perhaps someone who detested the rich or felt angry because German operas had been stricken from the Chicago repertoire.

Still, suspicions of an anti-American motive didn't totally subside. One witness told of overhearing three men in evening clothes in the lobby cursing America and Americans. They spoke loudly, in a German accent, said the witness. Investigators attached more credibility to the narrative of Julius Dalber, Maestro Campanini's secretary. Dalber told of seeing a small man hurry into the lobby and put on a derby hat as he headed for the door. "I didn't pay particular attention to him. A few seconds later, the bomb flared up…I rushed after him [but] he was already going through the outer door." Patrons sitting behind seat K-28, next to the empty seat where the device went off, also mentioned that K-28 was occupied by a man in evening clothes and a derby who abruptly left shortly before the flare-up.

Authorities at first dismissed the bomb as the work of an amateur. A New York police bomb expert, in Chicago on other business, declared, "This is one of the poorest [bombs] we have seen. I don't believe there was enough powder to crack the pipe." On closer examination, however, investigators found one end of the cylinder filled with heavy shot. The rest of the device contained sawdust and gunpowder. Had the fuse not failed and the cylinder become heated sufficiently, it would have exploded and caused serious harm, investigators revealed.

Federal agents did, in fact, arrest a German national, an interior decorator named Fred Miller, who said he had entered the United States from Canada. Miller told authorities that he had worked at the auditorium from 7:45 a.m.

to 4:00 p.m. the day the bomb fizzled but insisted he had nothing to do with it. His alibi of eating dinner at a specific restaurant; going to a saloon, which he named; and returning home by 9:00 p.m. held up, and he was released.

Fred Miller wasn't the last German native to come under scrutiny. Four days before the attempted bombing, the chairman and the president of the First National Bank received anonymous special delivery letters demanding $100,000. A second letter, which followed the auditorium incident, outlined the steps the bankers were to take if they wanted to avoid an attack on the "next place picked." Later, when a man approached a teller with a note containing further instructions, detectives were waiting. Under questioning, the man turned out to be a courier, randomly selected by an anonymous man who paid him $2 to present the note and collect a satchel. Police stuffed the bag with newspapers and told the man to continue following the directions he'd been given by his mysterious employer.

The courier led them to fifty-two-year-old Reinhold Faust, a naturalized citizen who'd come to the United States at age sixteen and had lived in Chicago for thirty years. Faust claimed he hadn't intended to hurt anyone but planted the bomb to scare the bank officers into turning over the $100,000. Investigators remained highly skeptical, particularly after they discovered another bomb, dynamite, gunpowder and nitroglycerine at Faust's home on North Richmond Street. A veteran detective wondered, "Why would he have such a large quantity of explosives unless he expected to make other bombs and to use them?" Money wasn't his only motive, Faust disclosed during a long, rambling confession. He still felt bitter about being discharged from the United States Post Office service for insubordination ten years earlier and hated "the wealthy and upper classes."

Faust was convicted of one count of extortion and sentenced to one to twenty years in the penitentiary. He was represented by famed defense attorney Clarence Darrow, who entered a guilty plea accompanied by the observation that his client was not "exactly right mentally" and should be "kept under observation." Faust's unwitting messenger, who had agreed to testify against him, wasn't charged. The Civil Service Commission awarded battalion chief Corrigan the city's Lambert Tree Medal for bravery. There is no record of Detective Sergeant Eisenberg receiving an award.

DEATH FROM ABOVE

THE WINGFOOT BLIMP CRASH
JULY 21, 1919

Commuters leaving downtown on Monday, July 21, who bought copies of the afternoon *Chicago Daily News* for the ride home came across a light-hearted and possibly facetious article that bore the headline, "Blimp, Sir? Off to Paris!" The lead declared, "Now we'll go blimping direct from Chicago to London, Paris, Berlin, Dublin, Rome and all points east" because the city was destined to become the "blimpopolis" of the Western world. Perhaps, but Lindbergh's solo flight across the Atlantic remained eight years in the future. The article was based on the observations of one Roger J. Adams of Pittsburgh, "who has just returned from Europe after making an exhaustive study of dirigibles, airplanes and commercial aeronautics." It was a time when blimps appeared to offer serious competition to planes as the conveyance of choice for air travelers. While *Daily News* readers were finding bemusement aboard their crowded streetcars or L trains, a tragedy involving a dirigible unfolded before some of their eyes. It would be a long time, if ever, before many among the horror-stricken would consider travel by blimp.

With the war over, the race was on to develop the commercial aviation industry, and the Goodyear Tire and Rubber Company of Akron, Ohio, was determined to be in the forefront. During the war, Goodyear built the first two airships used by the military. Both were constructed in a hangar at Chicago's White City amusement park, at Sixty-third Street and Cottage Grove Avenue, on the South Side. At the time war broke out, it represented the only available hangar in the country. After the war, the company's

hangars at Akron stayed in the hands of the military, so Goodyear returned to White City to assemble its first entry in the commercial field. The airship's components were shipped from Akron to the idle White City hangar, which had been facing demolition to make way for a picnic grove.

The Goodyear dirigible was named the *Wingfoot Express*, in honor of the company's logo, a stylized winged foot, which, in turn, took its name from a lake near Akron. A behemoth measuring 186 feet long and 50 feet across, the ship held a fuselage capable of carrying a crew of two and eight passengers. The *Wingfoot* was powered by two heavy rotary engines fueled by a pair of gasoline tanks and was capable of speeds up to sixty miles per hour. Its gasbag was filled with hydrogen.

Three weeks after the ship's components arrived at White City, the *Wingfoot Express* was ready for its trial runs. These were preceded by correspondence between company executives that expressed a desire for "big publicity," "a special stunt" and the presence of "prominent men on the first flight." Later, one of the officials denied that Chicago had been selected so thousands could witness the flights and asserted that the demonstrations were intended for "educational purposes."

Monday morning, July 21, after a week of preliminary tests on the ground, the *Wingfoot Express* stood ready to begin its ascent from White City. The valves had been adjusted, the gas tanks installed and all the instruments checked and found to be OK. The engines started with the first swing of the propeller and functioned perfectly. With a small cadre of army officers onboard, the *Wingfoot* rose at 9:00 a.m. and glided a mile west, then turned around, headed for Lake Michigan, skimmed the lakefront and landed in Grant Park. Shortly after noon, the ship made another brief flight and returned to the park. Everything continued to run smoothly.

Photographer Milton Norton, a skilled and popular figure in the Chicago newspaper community, joined the large crowds that had gone to the park for a close look at the beautiful silver dirigible. Norton was there to get shots of the *Wingfoot* on the ground. He had recently hired on at the *Herald and Examiner* after working as a staff photographer for the *Daily News*. Maybe he wanted to impress his new employer. More likely, he simply was a good newsman who saw a way to improve the story a hundredfold. Norton telephoned his editor and asked permission to fly aboard the *Wingfoot* on its third and final series of passes over the city. How could any editor discourage such initiative when spectacular panoramas were to be had to the exclusion of the other papers? Earl Davenport, White City's publicity director, also lobbied to be included, perhaps to better perform his own job, for the thrill of the ride or both. Initially, the *Wingfoot's*

manager, William Young, turned down their requests. The ship was new and still undergoing its shakedown, Young explained; the flight could be risky. Norton and Davenport persisted, and Young gave in. The photographer and publicity man joined pilot Jack Boettner and mechanics Henry Wacker and Carl "Buck" Weaver, for the flight, which began at 4:50 p.m. Boettner sat in front. Next came Davenport and then Norton, followed by Wacker and Weaver. Visibility was excellent, and winds were light. All wore parachutes.

The *Wingfoot* glided over the city at 1,200 feet. "Its grace, beauty and silent sailing," one publication observed, "contrasted it from noisy airplanes which citizens are accustomed to seeing." Pilot Boettner said he knew something was wrong when he felt the heat. The ship had been airborne for only about seven minutes, time for Norton to make just two photos.

"Looking back, I saw shots of fire on both sides of the rear end of the bag," Boettner later told police.

> *I watched the flames for a couple of seconds before I said anything to the other fellows. Knowing the ship was finished, I yelled, "Over the top, everybody." As I yelled, I felt the frame buckle, but by this time* [the others] *were beginning to slide over the sides. I think I was the last to jump, as I saw all the parachutes in the air when I was hanging on, ready to drop. I saw one of the parachutes was on fire.*

The flaming chute belonged to photographer Norton. On his deathbed at St. Luke's Hospital, he said,

> *The flames broke out behind me, suddenly. I figured it was about time for the getaway, so I slid over the side. There was great heat and lots of flame…I held on to the parachute with one hand and held my camera and plates in the other. I remember passing the Board of Trade Building, but that's all. I wriggled and twisted to get my parachute from the path of the flames but didn't succeed altogether.*

Norton plunged into La Salle Street, near Jackson, "like a rocket," according to one witness. He broke both legs and suffered massive internal injuries. During his final ordeal at the hospital, his thoughts turned to his camera and plates and whether he had captured the story. No one told him that his equipment had been smashed in the fall.

Boettner, an experienced balloonist, had much better luck. After his parachute "opened perfectly," he watched the flaming ship fall past him. He

This artist's work shows the tragic sequence of events as the *Wingfoot* crashed through the skylight of the Illinois Trust and Savings Bank. *Courtesy of the Fire Museum of Greater Chicago.*

went on to say, "The worst sensation I experienced was after my parachute opened. I began sliding down rapidly and looking up, I saw it was beginning to burn. In an instant it began to whirl, and it went around so fast I couldn't see where I was falling. I kept whirling around in the air until I lit."

Slightly dazed, the pilot landed on top of the Board of Trade Building on Jackson, at the foot of La Salle Street. He descended the fire escape with the intention of looking for the others but instead was met by detectives who arrested him. During his descent, Boettner said he saw mechanic Wacker below him.

"I could distinguish him by the leather coat he wore," said the pilot. Wacker followed Norton over the side and, like the photographer, saw his chute catch fire. As he neared the ground, he swung toward a building where some men were standing on a fire escape. He reached out for help, he related, but the men backed away, as if afraid. Wacker also landed in La Salle Street, seriously injured with a compound skull fracture, a fractured collar bone and three broken ribs. He was taken to Presbyterian Hospital, where he remained unconscious for days.

White City employee Davenport was unable to bail out. He was caught in the flaming gas bag and, badly burned, crashed to his death on the roof of the Illinois Trust and Savings Bank adjacent to the Board of Trade. Mechanic Weaver's chute also caught fire. His fall trailed in the path of the balloon as it plunged through the bank's skylight, a penthouse-like structure that rose from the center of the roof. Breaking through the iron supports that held the glass, the fuselage, with its two heavy engines and two gas tanks, smashed against the floor of the ground-level rotunda, where some 150 clerks and bookkeepers were working. Weaver's body followed an instant later. The bank had already closed to customers on its normally busiest day of the week, and the employees were close to completing their day. Had the accident happened a few minutes later, said president John J. Mitchell, "nobody would have been at work in the bank except the watchmen."

The bank was an imposing edifice, typical of La Salle or Wall Streets, fronted by classical Grecian columns that bespoke a temple of commerce. Set back from the expansive rotunda were the offices of the bank executives, which were visible but partly screened from the open area by a succession of interior columns. (Appropriately, the house organ was titled "The Columns.") The explosion of the gas tanks in the rotunda touched off a withering rain of fire, spewing flaming gasoline over everyone and everything within a fifty-foot radius. Employees had no warning.

"There was a shadow, and I looked up to the roof," said Harriet Messinger, a telephone operator stationed on the balcony above the rotunda. "Instantly, a crash sent the glass flying on the heads of those below. The girls hesitated, many of them stunned by glass or too frightened to run. Then the huge machine came through. It seemed to fill the bank with flame that searched out every corner. The heavy part with its engines and tanks fell to the floor and exploded. I ran to a window and called for help. I started to jump, but no one [below] made a move to catch me, so I ran to the street safely."

Several women did jump to the street, while others stood by the windows screaming. The rotunda was enclosed in a wire cage that had only two exits. Both women and men, some with their clothes on fire, scrambled to get out. One minute pandemonium reigned; then, in an instant, the marble rotunda stood deserted except for the dead and dying, either buried under the flaming mass of debris or trying feebly to crawl away. The intense heat precluded any rescue attempts. A 4-11 alarm from Box 52 at La Salle and Jackson summoned fourteen engine companies, five hook and ladders, two squads and the top brass of the fire department, but there wasn't much they could do. Half an hour went by before bodies buried under the fuselage could be removed. One woman lay crushed beneath one of the rotary engines. Firemen battled the flames for nearly an hour. Some climbed to the roof but found they couldn't do anything except look at the shattered skylight and the terrible scene below. Before the firemen's arrival, employees using the emergency fire hoses made a start at controlling the flames and were able to move some of the less seriously injured out of further harm's way. Ambulances raced to the scene from every direction, and police threw a cordon around the bank to control a crowd estimated at twenty thousand, not counting those who looked on from nearby buildings.

"I carried out four dead bodies," said police officer W.F. Higgins. "Two of those were near the rear exit from the rotunda. Their clothing was still smoking when I arrived…It seemed that they had been directly under the blast of fire when the balloon fell in and they had to run, but the flames from their own clothes were too much."

Assistant cashier F.I. Cooper left his desk to accompany a messenger into the vault area. He'd been away only a few moments when "the body of a man [Weaver] so badly burned and mangled that I could not tell at first that it was a man at all came hurtling through the air and fell at my very feet."

The final toll amounted to thirteen dead—ten bank employees along with the three men from the *Wingfoot*. Twenty-eight were injured. The skylight, whose expanse approximated that of the rotunda, ended up a charred mass on the

floor, with telephones, light fixtures, adding machines, typewriters, desks and chairs jumbled in the mix. Cleanup work began three hours after the accident, and the bank opened for business as usual the following day with one poignant exception. From 11:30 a.m. to 11:35 a.m., during the bank's busiest time of day, all business activities ceased, and a sorrowful silence fell over the institution. Not a call got answered, not a typewriter clicked, not a check got cashed or deposited. Throughout the cavernous building, bank officials and employees rose with heads bowed. Some made their way to the spot where the crash had occurred. Many customers at first found themselves puzzled by the suspension of business until they were quietly informed of the tribute taking place. Then they, too, joined in the moments of silence.

President Mitchell assured one and all that reports of lost cash, checks or bonds were untrue. All cash and securities were locked up, he confirmed. Despite the horrific nature of the accident, Mitchell said only $25,000 in damage resulted, fully insured.

When he recovered sufficiently to tell his version of events, more than two weeks after the crash, Mechanic Wacker clarified some uncertainty over the *Wingfoot*'s final moments. "I was the first to jump," Wacker stated. "I don't know who jumped next. When a blimp starts burning, you don't look around. I went [over the side] just as soon as Boettner called to me, and I saw the flames a little above the equator line in the rear of the [gas] bag." He emphatically denied two published reports—that he helped photographer Norton bail out and that he attributed the fire to an engine backfire. Wacker said he didn't know what caused the accident but suspected static electricity.

With the war over, no one raised the possibility of sabotage, but a host of other theories surfaced. Coroner Peter Hoffman convened a jury to sort through the conflicting opinions of various experts and witnesses. Among their viewpoints:

*A gasoline explosion in the engine's flash pan may have blown out a cylinder head

*Silk diaphragms, being tested for the first time, may have rubbed against each other, causing friction that ignited a gas leak

*A spark from one of the engines set the gas on fire

*The gas bag was protected from the engines and therefore couldn't have been ignited by sparks

*There was no explosion; the gas bag was practically filled when it hit the bank building

*The balloon was overfilled with gas, and the sun's rays caused it to burst

*The flames were yellow, indicating that the fabric, not the gas, was burning

*The fire started near the nose of the bag, not the rear

Hoffman and his panel ultimately determined that the cause could never be established, and their most valuable contribution would be to urge the passage of laws promoting the safety, while not hindering the advancement, of air travel. Among other measures, they recommended the licensing of pilots and a ban on flying over large cities. National and local officials didn't require much urging. A bandwagon was rolling, as it usually did in the aftermath of tragedy, and many scrambled to climb aboard.

"WE NEARLY LOST THE WEST SIDE"

The Burlington Office Building Fire March 15, 1922

G iven the magnitude of the fire, the death of one firefighter and no civilians seemed to defy the odds, yet the Burlington Office Building fire in the early morning of March 15, 1922, ranks among those that had the greatest impact on the Chicago Fire Department. This major blaze west of the Loop is also known as the Union Station District fire because of its proximity to the huge railroad depot just to the north.

A 3-11 alarm with ten special alarms was sounded for the inferno that threatened to spread to the West Side and replicate the Great Fire of 1871. Like the Great Fire, the Burlington proved embarrassing to the department, which found itself ill-prepared to control rapidly spreading flames in a number of large buildings, including the fifteen-story headquarters of the Burlington Railroad. Once again, lack of a high-pressure water system became a factor. City engineer Alexander Murdock complained after the fact that he hadn't been notified of the fire so he could order an increase in water pressure at a pumping station. Murdock said extra pumps were placed in operation at the Harrison Street Pumping Station only because station hands saw the rush of fire equipment and realized there was a serious blaze somewhere downtown. According to first assistant marshal Edward Buckley, the fire department wasn't responsible for notifying the city engineer of fires no matter how large. Besides, Buckley added, every pumping station came equipped with a fire alarm box, just like a firehouse.

The horrific damage caused by the Burlington Building conflagration resembles the aftermath scenes of the Chicago Fire of 1871. *Courtesy of the Sully Kolomay Collection.*

The flames broke out in a two-story building at 517 West Jackson Boulevard, a block east of the Burlington, and spread to other structures in the square block bounded by Canal, Jackson, Clinton and Van Buren Streets. From there, the fire spread across Clinton Street and ignited the Burlington at 547 West Jackson Boulevard. The blaze also engulfed other buildings and destroyed the Canal Street Station of the West Side Electric Elevated Line, creating a massive problem for thousands of commuters headed to the Loop during the morning rush hour.

The extent and intensity of the fire were shown by the fact that, of the eleven buildings destroyed or heavily damaged (other than the Burlington), three stood eight stories tall, two at seven stories, one at five stories, three at four stories and the remainder at two stories. Scores of businesses were burned out.

A clerk at a nearby post office spotted the flames burning through the roof of the building at 517 West Jackson Boulevard. He told a postal truck driver to go to the firehouse about two blocks west of the burning building to report the fire. The clerk went to Canal and Van Buren and pulled Box 276. Unfortunately, only minutes earlier, the companies responsible for reporting to that location had responded to an alarm from Box 277 for a small blaze

at 110 South Canal Street. That location was less than three blocks from the Jackson Boulevard fire. Box 277 had been pulled three times in less than an hour. Two were false alarms.

Although much of Chicago's fire apparatus had been motorized by 1922, the first company to arrive at 517 West Jackson Boulevard was Reserve Engine Company 94 with a horse-drawn steamer and its horse-drawn hose wagon. The reserve engine shared quarters with Engine Company 5, which was motorized and had responded to Box 277. In other words, the more advanced equipment wound up at a virtual bonfire while the antiquated apparatus headed for one of the city's all-time worst infernos. Records indicate that Engine Five apparently never responded to any of the alarms sounded from Box 276 for the Burlington fire.

Probably based on the information provided by the postal truck driver, Reserve Engine 94 reported to the Main Fire Alarm Office at 12:50 a.m. that it was responding to a "company still alarm." Such an alarm usually came from someone walking into a firehouse to report a fire. The alarm office immediately struck a "special box" for Box 276, sending three additional engine companies, a hook and ladder, two fire insurance patrols, the fireboat *Graeme Stewart* (the South Branch of the river was about two blocks east of the fire), two battalion chiefs and first assistant marshal Buckley.

Buckley arrived within minutes and immediately ordered the crew of Reserve Engine 94 out of the 517 West Jackson Boulevard building because fire was dropping down from the second floor. Buckley also noticed that the upper floors of the seven-story building around the corner at 309 South Clinton Street were heavily charged with smoke. At 12:54 a.m., Buckley called for a 2-11, which ordered a response from five engines, two hook and ladders, a squad, two fire insurance patrols and a battalion chief. Four minutes later, he requested a 3-11, which brought four more engines, a hook and ladder, a squad, the fireboat *D.J. Swenie*, chief fire marshal Thomas O'Connor and six assistant fire marshals. Only two minutes later, at 1:00 a.m., a special alarm was requested for five additional engines. A total fifty-one engine companies, six hook and ladders, seven squads, two fireboats and four fire insurance patrols would respond. Chief O'Connor later described the blaze as the worst in Chicago since the Great Fire of 1871.

The intensity of the blaze indicated to Buckley that the fire had been burning for some time before the arrival of Reserve Engine 94. This fact, plus the earlier false alarms and the fire nearby, led to suspicions that the fire was the work of an arsonist, but no one was ever prosecuted. Although some

of the structures had fire sprinklers, the rapid spread of the flames rendered them ineffective.

The lone fatality occurred early in the battle when a wall collapsed unexpectedly. James McGovern, a member of Fire Insurance Patrol 1, was the victim.

As the firemen battled on, one of the assistant marshals noticed that the wooden frames above the eighth floor of the Burlington were being ignited by radiant heat. This phenomenon was followed by another, which he described as "a hail storm" of broken window glass raining down into the street. Further complicating the situation and further endangering the firemen was a shower of iron window sash weights that fell from the upper floors and imbedded themselves in the pavement. One account of the blaze said the sash weights "stuck straight up in the street like a forest." For a time, the fall of broken glass and sash weights prevented firemen from entering the building.

Radiant heat, along with super-heated gases and burning embers, had broken the windows and ignited combustible material on the upper floors of the Burlington. The contents on the floors above the eighth all caught fire about the same time. It was reported afterward that the upper floors were much more heavily damaged than the lower floors, due primarily to the inability of firemen to get sufficient water higher up because the area lacked a high-pressure water system. Firemen who had difficulty getting to the top floors were greatly assisted by heroic building elevator operators.

The men used hoses connected to standpipes on each floor of the Burlington to mount the main attack. That the standpipe connections were not located in the stairwells created a serious problem. This meant firemen had to connect their hoses in open areas affected by flames, heat and smoke. To add further aggravation, the connections stood so far above floor level that men had to be lifted by their comrades to connect the hoses.

What happened in the Burlington brought to mind the warning issued by Chief Horan a dozen years earlier when he described "a six-story fire department." Horan said that the lack of a high-pressure water system made it necessary for firemen to drag their hoses up to the fire "or wait till it burns down to us." He said a high-pressure system would make it possible to attack fires in taller buildings from the outside.

The night of the Burlington fire, the department had no water tower rigs in service, which could have directed powerful streams into the building at higher levels. At one time, the department had two horse-drawn water towers. They were never motorized. One had been taken out of service in

Only months after the Burlington Building conflagration, the Chicago Fire Department gets its first motorized water tower. Parked to its left is High Pressure Service Company Number 1, the department's answer to the lack of a high-pressure water system. In 1924, Water Tower 1 would be heavily damaged at the Curran Hall fire. *Courtesy of the Ken Little Collection.*

1902, the other in 1920. Also lacking were deck guns, another apparatus that could have delivered similarly powerful streams.

In a 1922 survey, the National Board of Fire Underwriters sharply criticized the fire department for its lack of water towers and deck guns and found other deficiencies. The Chicago Board of Underwriters, in its report on the fire, cited seven conditions that contributed to the disaster:

> *Tardy notification to and consequent delayed arrival of the fire department; unprotected exterior openings; non-automatic fire doors; combustible buildings with poor floor cutoffs; heavily loaded and oil-soaked floors and numerous tenants with hazardous occupancy; narrow spaces between buildings acting as flues and making access at first difficult and later impossible; unprotected steel floor and wall framing; sprinkler protection rendered impotent by large numbers of heads opened on many floors.*

The Chicago Underwriters disputed the claim that the Burlington was a "fireproof building." According to the insurance group: "It is absurd to expect that a building which is built partly of fire resisting materials and partly of combustible materials and filled with combustible contents will not

be materially injured both as to structure and contents when subjected to high temperatures."

Damage caused by the massive fire was estimated at $8 million, of which $3.5 million was covered by insurance. In a most unusual commentary on the fire, the architect who designed the Burlington said its destruction actually was a blessing in disguise because the building served as a firebreak, a bricks-and-mortar and steel barrier against the spread of the flames.

"The fire was bad luck for the Burlington Building but certainly was good luck for Chicago," Charles E. Fox told the *Chicago Tribune*. "The Burlington has contributed the whole cost of saving the entire West Side. If it hadn't been in the direct path of the fire, nothing on earth could have stopped the flames from wiping out the entire West Side."

The Burlington building fire apparently proved to the fire department that it could no longer wait for city hall to provide a high-pressure water system. The city had been kicking the can down the road for decades. About eight months after the fire, a new rig went into service. It carried the name "High Pressure Service Company Number 1." The department shops had reworked a 1918 Mack tractor. It sported two deck guns and carried a three-and-a-half-inch hose. Several hose lines could be connected from engine companies to each of the guns, which, in turn, could provide extremely powerful streams of water.

GOOD FRIDAY ARSON

THE CURRAN HALL FIRE
APRIL 18, 1924

The year 1924 ranked as the second deadliest one in the fire department's history. Only the dark year of 1910 saw more firefighters die in the line of duty, and twenty-one of those twenty-three fatalities occurred at the stockyards fire. The eighteen men who died in 1924 lost their lives at eight separate locations. The most notorious, by far, was a box factory at 1363 South Blue Island Avenue on the near Southwest Side, a landmark that had served previously as a neighborhood social hall for fifty years. The site was less than a mile from the O'Leary barn where the Great Fire of 1871 originated. Nine firemen and one civilian were killed by the Curran Hall fire of April 18, 1924—Good Friday—the heaviest department toll ever except for the Stock Yards Fire of 1910. Compounding the tragedy was a coroner's jury finding of arson.

Many firemen had already put in an exhausting day before Curran Hall went up about 7:30 p.m. That morning, around nine o'clock, fire broke out in a former Nelson Morris hog slaughterhouse at Racine and Exchange Avenues. The building was being used as a corn warehouse by Armour and Company, following its merger with Morris the previous year. A spark from a switch engine was believed to have started the blaze in the five-story structure. Before the flames were extinguished, the stubborn fire had drawn sixty engine companies, roughly half the department's total, under the command of chief fire marshal Edward Buckley. Engine Company 62 responded from 114th Street and Michigan Avenue on the far South Side, more than ten miles

away. High winds whipped the flames to several nearby buildings, which firemen were able to save. Total damage came to $500,000. Losses included several carloads of corn and seventy-five automobiles. No one was injured, but an Armour safety supervisor narrowly escaped death after he climbed to the roof of the burning building and found his descent blocked. Firemen rescued him.

Less than eight hours later, many of the same companies found themselves back in action at the former Curran Hall. Once more, the Nelson Morris connection became evident as the responders confronted a harrowingly similar situation to that faced by Chief Horan and his men in 1910. When the first companies reached the scene, flames were raging through the Elegant Box Company factory, which manufactured pasteboard boxes on the ground floor. Battalion chief Michael Kerwin of the Seventh Battalion, the first senior officer to reach the fire, watched the flames sweep the second floor, which was occupied by the Leather Sporting and Novelty Company and the Illinois Sporting Goods Company. That was when he called in a 4-11. The alarm brought Fifteenth Battalion chief Henry Kerr and his men. It would become the final call for many of them.

Chief Kerwin said later that he spotted flames on the front stairs after firemen had broken through the front door.

"I sent Engine Company 18's crew up the front stairs," Kerwin related, "and Engine Company 6's up the back." He said both stairways were on fire, even though they stood twenty-five feet apart with no flames in between. It looked like an oil fire, Kerwin noted. "It just seemed to be flowing toward us, down the stairs."

After directing the attack on the blazing stairways, Kerwin went to the roof of a building immediately south. The chief didn't like the looks of what he saw and sent his driver to order the men inside Curran Hall, on the upper floors, to get out, posthaste. The command didn't come soon enough.

Lieutenant James Brichta of Engine Company 107 was on the fire escape at the third floor of the burning building when he saw two of his own men, six from Engine Company 5 and seven from Truck 12 fighting the fire inside under Chief Kerr's command. Brichta said Kerwin's message to Kerr was: "I don't believe that this building is worth a fireman's life, and I think we had better get out." The observation recalled Chief Burroughs's to Horan at the 1910 stockyards fire: "You'd better stand down, Chief." On this occasion, a few more seconds elapsed before disaster struck. Kerr agreed to pull back, and Kerwin arrived to lead the men down the fire escape.

"[Firemen] Francis X. Leavy and Francis Kelly were just behind me on the fire escape," Lieutenant Brichta related, "and I was but a few feet from the ground when the explosion came. I remember flying through the air and landing somewhere in the street. All around me were piles of bricks and stones. I saw Kerwin was safe, but I realized that both Kelly and Leavy were buried under the ruins."

Tons of debris smothered men and apparatus in the street after the walls blew out with terrific force. Kerr was one of the first caught beneath. One fireman was blown through a plate glass window across the street. Pipeman John Cella of Engine Company 5 was still on the third floor when the walls toppled.

"I heard a cracking of glass," Cella remembered. "Something told me what was coming. Then I felt things drop out from under me. Down I went with a mass of bricks, stones, flying glass and burning wood. I was half standing on Blue Island Avenue, and the rocks and bricks were almost up to my hips. The fellows rushed to me, pulled me out and put me in a patrol wagon."

Cella was one of a group of men who were caught when the roof and the third and fourth floors dropped into a pile of flames below. Some made it to the front windows, where members of Truck Company 12 had placed ladders and were on their way up to the third and fourth floors with leads of hose. A newly acquired water tower had been stationed at the mid-point of the front wall to direct streams into the upper windows. The men climbing the ladders seemed at cross-purposes with those already inside, looking for a way to descend. An avalanche of brick instantly linked them in a common fate. The men on the ladders, along with some working from ground level, were hurled into the basement. Debris buried the water tower, as well as Engine Company 5 and Engine Company 107. Eight other pieces of equipment were damaged.

Truck Company 12, with quarters at Thirteenth Street and Oakley Avenue, was all but wiped out. Six members of that unit were among the nine fire department fatalities. Only one, Peter Lee, escaped death or serious injury.

Eight of the firemen, plus one civilian, William Behr, were killed instantly. According to fire historian Ken Little, Behr was a fire fan who rode to the blaze aboard one of the rigs. Fireman James Carroll of Truck 12 died of injuries a week later. Carroll's ill-fated truck mates included Lieutenant Frank Frosh and firemen Edward Kersting, Samuel Warren, Thomas Kelly Sr. and Jeremiah Callaghan. Captain John Brennan of Engine Company 5 was the highest-ranking victim. One of his men, fireman Michael Devine, also perished, along with fireman Leavy of Engine 107. All but Frosh and Callaghan were married and had children. Seventeen firefighters were

injured, including battalion chief Kerr, who sustained broken legs, a skull fracture and internal injuries when he was caught on the fringe of the cascade of bricks.

The shadow of death that fell on the men of Truck 12 extended to the only member of the doomed Truck Company 11 to survive the 1910 Stock Yards Fire. Lieutenant Claus Clausen, now a member of Engine Company 87, suffered a fatal heart attack while serving as an honorary pallbearer at Callaghan's funeral. Clausen was stricken as he accompanied Callaghan's casket into St. Lawrence's Church on the South Side for the funeral mass. His death was classified as occurring in the line of duty, which indirectly raised the department toll from Curran Hall to ten.

By the time Curran Hall collapsed, the area around Thirteenth Street and Blue Island Avenue was teeming with thousands of spectators, frantic relatives of the missing among them. Squads of police, including men on horseback, held them back. Every rooftop for blocks around was filled with onlookers. Ambulances and police wagons converged on the scene from all directions, joining a team of surgeons, interns and nurses from nearby Cook County Hospital.

It was as if the city and fire department were reliving the 1910 Nelson Morris tragedy. Police and firemen dug desperately through the night, removing the dead and praying that others might be found alive. Fire commissioner John Cullerton ordered out hoisting companies and searchlight units. Private derricks supplemented them to aid in lifting debris from buried firemen. The search parties ignored tottering sidewalls directly above them. Twice, portions of the walls crumbled, but the men worked on. The decision to move in portable lighting proved prescient when the falling walls took down power lines and plunged the rest of the neighborhood into darkness. Police officer Thomas Kelly Jr., of the Maxwell Street Station, stepped through a group of firemen to help carry a body on a stretcher across the piles of smoldering bricks. He glanced down at the blackened face. It was that of his father, Thomas Kelly Sr., of Truck Company 12.

Before the fire, the big red apparatus doors of the firehouse at Thirteenth Street and Oakley Avenue had been open all day. The long, hard winter was not far enough behind to let a mild day go unappreciated. The officers and firefighters of Engine Company 107 and Truck Company 12 felt restless after a winter of icy, all-night fires. The routine daily chores were running behind schedule. So, in the late afternoon with shadows falling, the firehouse windows were still being cleaned.

Frank Leavy was killed at the Curran Hall fire and apparently left behind a memento that would prevent his name and death from being forgotten anytime soon. *Courtesy of* Firehouse *magazine.*

Firefighter Francis X. Leavy was washing the inside first-floor window. A hardworking man, Frank Leavy was a dedicated thirteen-year veteran. He joined the fire department after an eight-year stint in the navy, in which he had enlisted by falsifying his age; he had been fourteen. In 1915, Leavy married Mary Purcell, and by 1921, he was the father of a girl and boy. Struggling to raise a family on his $2,200 annual income, Leavy drove a cab and did odd jobs to make extra money. Friendly, cheerful Leavy was beloved by his family, neighbors and comrades in the firehouse.

Today, the usually jovial fireman was uncharacteristically quiet and sullen. His work and that of the other firefighters had been interrupted several times as the register, a stock ticker–like device, tapped out signals for the fire in the stockyards that had grown to four-alarm proportions. Although the engine, hook and ladder and the Fifteenth Battalion chief buggy were not on the response card, every man knew any or all could wind up at the big fire if special alarms were sounded.

As they waited for a possible call, Leavy wasn't making much progress on the house window. "This is my last day on the fire department," he said to fellow firefighter Edward McKevitt.

McKevitt was surprised to hear such a remark. Just a few hours earlier, Leavy had been talking happily about his plans for the next day. McKevitt

had never seen Leavy so dejected and suspected it might have something to do with Good Friday or working on Easter. He would later recall vividly that as Leavy told him of his grim feeling, he placed the palm of his left hand against the window pane. Leavy's right hand, holding a soapy sponge, made circles against the glass.

The strangeness of the moment was interrupted. Box 372, a mile and a half to the east, had come across the Big Joker alarm register. Now, minutes later, Box 372 was being tapped out again, a special alarm, because some of the companies on the response card had been sent off to the stockyards fire. The house bell began ringing.

Leavy dropped the sponge into the bucket and made for the back step of the 1921 Ahrens-Fox pumper. Rivalry among fire companies was still rampant. It had grown up during the days of horse-drawn fire apparatus, those days having ended in Chicago just the year before. Rivalry existed even in the house at Thirteenth Street and Oakley Avenue.

The small red roadster carrying the chief and his driver was first out. The chain-driven pumper, with its distinctive, gleaming brass pressure ball and pumping equipment mounted at the front, began rolling as the men on the back step were still donning boots, coats and helmets. Up front in the open cab, the engineer swung the pumper into Thirteenth Street. Engine 107 was the easy winner. By the time the much longer Truck Company 12 had been cranked up and had pulled out of the station, the pumper was almost a block away. From Truck 12's open cab, lieutenant Frank Frosh waved to several neighborhood youngsters. In less than an hour, Frosh and seven of his mates would be dead.

The next day, Holy Saturday, was cooler and cloudy but the sun still occasionally shone through. The large red doors of the firehouse at Thirteenth Street and Oakley Avenue were closed, and inside, the few survivors of Friday's shift and the physically unscathed second shift spoke in hushed tones. McKevitt was telling several firefighters about events leading up to the fatal alarm. His eyes were red, his face unshaven, his hair uncombed. McKevitt was physically and mentally drained, and it was difficult for him to explain what had happened. His voice broke, and tears welled up in his eyes. As he spoke, McKevitt noticed a strange mark on the firehouse window. He moved closer and stared at it. "My God, it's Leavy's hand!" he whispered, as if to himself.

The other firemen gathered around and stared at the apparent apparition. On the glass was the outline of a hand placed flat, with fingers extending upward, against the pane. The palm and five fingers were clearly visible.

Fifteen years after Curran Hall went up in flames, a fireman at the quarters of Engine 107 points out the handprint believed to be that of Frank Leavy. *Courtesy of* Firehouse *magazine.*

McKevitt told the others how he had seen Leavy cleaning the window and place his hand on the glass shortly before the fatal alarm. He also told them about Leavy's mysterious premonition of death. "Wipe it off," said one of the firemen, disturbed by what he saw. Several others quickly agreed. McKevitt hesitated and then took the sponge from the bucket where Leavy had left it the day before. He began rubbing on the print, but it would not wash off. He rubbed harder, but it was still there. Other firefighters tried. The day-old water was dumped in favor of hot, soapy water. It made no difference. The firemen tried ammonia. They tried to peel off the print with a razor blade. Strong liquid and powder soaps were used. One member even went outside to wipe off the print, convinced that it was on the outside and not the inside of the glass. The men were frightened and mystified.

Leavy's wake was held over Easter weekend in the family home, as was the custom of the day. Hundreds of mourners, many of them firefighters, trooped into the small bungalow on South Whipple Street to pay final respects. The following day, Frank Leavy was buried at Mount Olivet Cemetery on the far Southwest Side.

With great fanfare, Commissioner Cullerton announced a fund drive to assist the survivors of the deceased firemen. Mayor Dever appointed a "Committee of 100," headed by fifteen aldermen, to oversee the citywide campaign. They established a goal of $200,000. When the effort concluded in July, only a little more than $47,000 had been collected. Each fireman's family received about $5,000. They agreed to give the balance to the family of William Behr, the civilian killed in the fire.

Evidence of arson at Curran Hall began to snowball:

*Other firemen besides Chief Kerwin told of seeing flames in widely separated locations.

*The off-duty streetcar conductor who turned in the first alarm said the initial flames were coming from the roof, but when he returned from the alarm box, the ground floor was on fire.

*Several witnesses, firemen among them, reported that the flames seemed to be fed by a liquid.

*Others, including a firefighter, told of seeing several suspicious boxes that exploded upon contact with the flames.

*A fourteen-year-old neighbor boy told his parents he saw a man run from the point of the building where the fire was spotted minutes later.

*The fire insurance policy of one of the tenants had been raised a month earlier from $20,000 to $32,000.

*A business colleague of the tenant estimated that the company's machinery was worth no more than $2,500.

*An employee of the firm said he was instructed to not lock the back door Friday night.

Coroner Oscar Wolff declared the fire a clear-cut case of arson-for-profit. "I intend to show…what persons had an interest in setting fire to that building," Wolff stated as the blue-ribbon coroner's jury got down to business. "It is absolutely sure that the fire was incendiary." Already in custody at the Maxwell Street police station were Samuel Moore and Leo Udell, owners of the Leather Sporting and Novelty Company, and an associate named Samuel Polinsky. The leadoff witness at the inquest, a neighbor who lived across the street from the burned out building, said he was certain the fire started in the Leather Sporting concern.

On April 22, four days after the fire, the coroner's jury returned a verdict of murder by arson and ordered Moore, Udell and Polinsky held over to the grand jury. On May 8, the grand jury indicted Moore and Udell on charges of murder by arson but declined to deliver a true bill against Polinsky. Calling arson "a cold blooded disregard for human life" that endangers the lives of firemen and civilians alike, a *Chicago Tribune* editorial called for the guilty to be hanged if arson could be proved. Almost two years after the Curran Hall fire, Moore and Udell were acquitted by a jury, which concluded that no evidence existed to prove that the pair had started the fire. Firefighters, particularly those at Thirteenth Street and Oakley Avenue, felt betrayed.

In the days following the fire, word of the mysterious handprint began to spread. People visited the firehouse to examine it. Newspaper stories brought out more of the curious. Some days saw a seemingly continuous stream of visitors. Many wanted to touch the handprint, much as the devout would touch a sacred relic. A firefighter usually would stand by to keep matters under control and ensure that the window didn't get broken. Dozens of times, firemen were asked to repeat the story behind the print. An expert from the Pittsburgh Plate Glass Company came to the firehouse to scrub the print with a special chemical cleaning compound. The print remained, and the expert departed, mystified. An employee of the city's personnel department appeared with a copy of Francis Leavy's thumbprint. He compared it with what he saw on the glass and said it indeed appeared to be Leavy's.

Some firefighters felt "spooky" when they pulled night watch alone near the window. For some, the handprint proved such an uneasy reminder that they put in requests for transfers. Each week, a company member would wash the window, knowing that no matter how hard he tried, the mark would remain.

There was some talk about removing the pane and placing it elsewhere for safekeeping, but that proposal didn't get far. That handprint remained for a reason, many believed, and superstitious firefighters decided it best not to tamper with it.

As time passed, people still knocked at the firehouse door, asking to see the handprint and hear its story. An occasional reminder in the newspaper or on the radio would result in a renewed flurry of interest. In January 1939, almost fifteen years after the Curran Hall fire, a newspaper article titled "Hand of Death" retold the story with a flourish.

Death's hand, stained in awesome mystery on a window pane, today has aroused the curious and intrigued the superstitious throughout Chicago…

Hardened to sights which make strong men quake, firemen through the years still cannot become used to dead Leavy's hand up there on the glass. Neighbors and others stare fixedly at the impression of the dead man's hand. Sometimes they tremble a little, and hurry away to contemplate impossible things that happen.

While many flocked to see the handprint, Leavy's widow, Mary, and daughter, June, were not among them. Young Frank did go to the firehouse to examine the print but came away refusing to admit that it might be his father's. The younger Leavy eventually followed in his father's footsteps and joined the fire department on April 18, 1945, the twenty-first anniversary of his father's death.

Many never questioned the authenticity of the handprint. Some thought it had to carry some supernatural purpose, possibly a reminder to pray for the dead or serve as a memorial to those who had been killed. The more prosaic believed that the handprint came with the window, the result of a manufacturing quirk not spotted earlier. Still others subscribed to the theory that Leavy's premonition of death had made him so nervous that his body excreted some chemical in his perspiration. They believed that when his perspiring hand touched the pane, the chemical etched his print into the glass.

Over time, the mysterious handprint became part of the natural order of things to the firefighters who worked out of the station. Then, on April 18, 1944, exactly twenty years to the day after Frank Leavy lost his life, a boy delivering the afternoon paper accidentally smashed the window with a rolled-up edition. A story in the *Chicago Times* explained, "The famous pane was shattered in a thousand pieces and Leavy's hand—if such indeed it was—withdrew forever from the living world."

Today, the site of the former Curran Hall is occupied by the Congressman George W. Collins senior citizen housing complex, named in honor of a Chicago lawmaker who, like the victims of the 1924 fire, met a tragic end. Collins, along with dozens of others, was killed in a 1972 airliner crash at Midway Airport. Across Blue Island Avenue and slightly north stands the modern quarters of Engine Company 18. The firehouse on the northeast corner of Thirteenth Street and Oakley Avenue was torn down in 1971. The lot remains vacant, as do those on the other three corners of the intersection.

TRAPPED!

THE SANITARY DISTRICT TUNNEL FIRE
APRIL 13, 1931

Following his electoral victory and purge of former mayor "Big Bill" Thompson's people, Mayor Anton Cermak escaped to Miami Beach to unwind. His holiday was interrupted five days after the inauguration by some dreadful news. Eleven men—four firefighters and seven laborers—had been killed when fire and poisonous gas filled a Chicago Sanitary District sewer tunnel under construction thirty-five feet below ground at Twenty-second and Laflin Streets on the near Southwest Side. (By sheer coincidence, Twenty-second Street would be renamed Cermak Road not long afterward.) During the protracted drama, Chicago's firemen would risk death and serious injury in a very small place to save not only strangers but their own comrades as well. No one would have expected anything different from them.

About sixty men—including carpenters, concrete masons and laborers—were working on the 450-foot-long tunnel, which was 17 feet high and another 17 feet wide. Running east to west under Twenty-second Street, the tunnel would connect to another leading to a sewage treatment plant scheduled to be built in Stickney, a suburb some eight miles to the southwest. At about the midpoint of the tunnel, a smaller work tunnel extended 40 feet to the south where a shaft with a construction hoist offered the only means of entering or exiting the tunnel complex.

Some precautions had been taken to protect those working below. Fresh air was pumped from above ground into air chambers at each end of the

tunnel. The air chambers came equipped with steel walls and heavy, steel air-lock doors to separate them from the rest of the tunnel. The west end of the tunnel was occupied by a decompression chamber ahead of the air chamber. The decompression chamber also had a steel wall and steel air-lock door. To reach the air chamber, someone would have to walk through the decompression chamber.

The steel doors were left open so air could circulate throughout the tunnel and vent itself out the hoist shaft. The fresh air would help prevent accumulations of potentially dangerous "swamp gas." At the same time, the atmospheric pressure in the tunnel would be equalized with that above ground. This would help prevent the possibly fatal condition known as "the bends," which is caused by sudden changes in atmospheric pressure. The purpose of the decompression chamber was to treat any victims of this condition. Despite these precautions, human error would result in a disastrous fire on that Monday in April 1931.

At approximately 6:00 p.m., one of the workers reported to construction superintendent Morris Cahill above ground that a smoky haze had formed along the tunnel's ceiling. The two men rode the hoist down but could not locate the source of the smoke.

Cahill returned to the surface and helped form a small group of workers armed with fire extinguishers that descended into the tunnel where the smoke had grown thicker and conditions were rapidly deteriorating. The party was met by fleeing workers.

The worker/firefighting team fell victim to the smoke and was forced to abandon the tunnel without tracking down the location of any flames. Superintendent Cahill was overcome by smoke and had to be assisted to safety. A call finally was placed to the fire department about thirty minutes after the smoke was first noticed. As often happened in fires that turned tragic, long delays in notifying city firefighters preceded the later tragedy. Within minutes of getting the alarm, Engine Company 23 pulled up on the scene from its quarters less than half a mile away. Next to arrive was Truck Company 14 from its house about a mile away. Also answering the "still" alarm was Chief Thomas Geary of the Eighth Battalion, Squad 8 and Fire Insurance Patrol 3.

Overcome earlier, Cahill volunteered to descend again and guide eight firemen from the engine and hook and ladder through the tunnel complex. The firemen carried hand pumps and tools. When they reached the main tunnel, heavy smoke forced them to retreat into the work tunnel. Several firemen were overcome and needed assistance getting to the hoist. The

With fire department lights illuminating the scene and smoke pouring from the elevator shaft opening, rescuers work feverishly to save trapped workers and firemen. © McClatchy Tribune *News Service. All rights reserved. Distributed by Tribune Content Agency, LLC.*

superintendent was overcome a second time and needed to be carried out. Later, he would be overcome a third time during a rescue attempt.

By seven o'clock, it appeared that all of the workers and firemen had evacuated the tunnel. Soon afterward, a group of about ten workers agreed to go down and extinguish the fire. It's difficult to comprehend why the workers would be given permission to enter the tunnel after two failed attempts by both firemen and other workers. It would prove to be a fatal mistake.

When nothing was heard from the latest group of workers, several firemen were sent down to find them. In a short time, the firemen came up carrying an unconscious worker and reported that the tunnel was heavily charged with smoke and the other workers could not be found. Chief Geary was now faced with missing workers and a fire that couldn't be extinguished. He ordered his driver to report on conditions to the Main Fire Alarm Office and request that First Division fire marshal Patrick "Paddy" Pierce respond to the

scene. The sixty-year-old Pierce was a veteran of countless fires, but fighting one in a tunnel was undoubtedly not among them.

On arrival, Pierce wasted no time in forming a rescue team composed of hand-picked firemen whom he would lead into the tunnel. Accompanying them would be a young worker familiar with the tunnel's layout. Once Pierce and his rescue team, without benefit of gas masks, reached the tunnel, they began calling out to possible survivors. Hearing some faint calls for help, the rescuers headed west. About midway through the western half, they stumbled on two survivors who had been overcome. There was no way the team could head back to the work tunnel and get themselves and the survivors above ground. Because of intensifying heat and smoke behind them, the rescuers, who were becoming dizzy from the fumes, had to take the pair and continue moving west toward the safety of the air chamber. On the way, the rescuers picked up several more survivors.

A total of nineteen rescuers and survivors reached the decompression chamber and closed the steel doors behind them. They passed through that chamber and entered the air chamber. The men had two steel doors standing between them and the suffocating smoke. Fresh air was being pumped to them, but they faced one serious negative: they were trapped and unable to communicate their location or condition. Twenty firemen volunteered to go below and locate the latest missing persons. Several attempts proved unsuccessful because of conditions below.

With the situation worsening by the moment, Chief Geary requested a special call for more manpower and equipment. In response, the Main Fire Alarm Office sent eight more squad wagons to the scene. Also responding were chief fire marshal Michael Corrigan, two additional division fire marshals, fire department physician Dr. Harold Sullivan and Cook County coroner Herman Bundesen.

When Corrigan arrived and assessed the situation, he began selecting volunteers to descend into the tunnel. They went in pairs, wearing substandard gas masks with a safety rope tied around their waists. Because of the extreme heat and heavy smoke, they could remain in the tunnel only a short time. Once above ground, the volunteers would rest for a time, then rejoin the rotation to descend again. Many off-duty firemen showed up at the scene, volunteering to participate in the rescue efforts.

The fire was taking a heavy toll. Fireman Edward Pratt of Squad 8 and several workers had already died of carbon monoxide poisoning. Pierce and his team were missing, along with Captain James O'Neill of Truck 14, while

A diagram of the tunnel where the deaths occurred and firemen and workers were trapped for many hours. *Courtesy of Alex A. Burkholder.*

dozens of firemen and workers had been taken to hospitals. The situation was grim.

Suburban Oak Park's fire chief brought a newer type of gas mask to the scene. One fireman who gave it a try was twenty-three-year-old Irving Strom, a comparative rookie of Squad 8, who descended into the tunnel an astonishing fifteen times. Strom, who was paired with a fireman wearing an older mask, brought up at least five bodies before he was ordered by Corrigan not to make another descent. Other firemen had gone below as many as ten times. Everyone was frustrated because they couldn't fight the fire. If they flooded the tunnel to extinguish the flames, survivors would drown.

By midnight, six hours after the fire started, the confirmed death count included five workers and Fireman Pratt. Twenty-six firemen required

hospitalization for smoke inhalation. For two members of the rescue team, firemen William Coyne and William Karstens, the long, hot confinement proved too much. Saying they would "rather die fighting than die like rats," the men ignored Pierce's orders and left the safety of the air chamber to make a mad dash for the work tunnel. Their bodies were found later, about halfway to their goal.

As word of the disaster spread, a crowd estimated at ten thousand, including friends and families of the victims, gathered at the scene. Some 250 police officers were needed to control the onlookers. One of the policemen, officer Harry Fielder of the Marquette District Station, became an indirect victim. He was fatally injured at Twenty-second Street and Damen Avenue, about half a mile west of the scene, when his car was struck by a fire department ambulance rushing a fireman to St. Anthony's Hospital.

About two o'clock in the morning, Chief Corrigan placed an urgent long-distance call to a man named Peter Pirsch in Kenosha, Wisconsin. Pirsch was the owner of a prominent fire apparatus manufacturer that bore his name. Corrigan had been told that Pirsch had developed a new piece of equipment called a smoke ejector, which could be used to vent smoky fires. Basically, the device was a truck that came equipped with a giant fan that sucked smoke out of burning structures through a series of wide, ten-foot-long, flexible tubes.

Awakened by Corrigan, Pirsch had bad and good news for the chief. The bad was that the smoke ejector was not quite completed and tested. The good was that his company would get to work immediately, despite the hour, finish the unit and get it to Chicago posthaste. Pirsch called his son and his mechanics and told them to meet him at the plant as quickly as possible. Among the steps remaining were wiring the motor, installing the carburetor and distributor, putting on tires and turning over the motor for the first time. While Peter Pirsch undoubtedly wanted to play good Samaritan, he also clearly wanted to impress the Chicago Fire Department, heretofore not a good customer for his products.

Back at the scene, a mine rescue team from the state Bureau of Mines was arriving by train from Springfield. The members brought with them sophisticated, self-contained air packs of twenty-minute duration. But at this point, there was little the team could accomplish. The tunnel had become so hot that it was impossible to enter.

Corrigan employed his last stratagem at four o'clock in the morning. He ordered that two holes, fifty feet apart, be dug in Twenty-second Street above the tunnel. Work began almost immediately. First, the cobblestone

The Chicago Fire Department did not purchase Peter Pirsch's smoke ejector but built its own. Smoke Ejector 1 is pictured here in 1957 and was still in service. It would finally be retired in 1961, after almost thirty years. *Courtesy of the Ken Little Collection.*

pavement had to be removed by workers using jackhammers. Next, steam shovels would dig down to the top of the tunnel, seventeen feet below. Once there, the jackhammers would be used again to penetrate the concrete roof of the tunnel. One is forced to wonder why the decision to dig had to wait until ten hours into the disaster.

The gravity of the situation, as measured by the fire department brass, became more apparent when an order was issued at 4:10 a.m., canceling all days off. This meant that beginning at 8:00 a.m., all members of both shifts would be working. At 5:45 a.m., as digging in the street progressed, word came from Kenosha that the smoke ejector, its paint still not quite dry, was ready to make its trek to Chicago. Peter Pirsch had done in three hours and forty-five minutes what seemed impossible. With the help of police escorts along the way, the smoke ejector arrived at approximately 7:15 a.m., eighty-eight minutes after leaving the Pirsch plant across the Wisconsin state line. The truck was parked near the hoist shaft. The flexible tubing was connected to the shaft opening, and in less than fifteen minutes, a large volume of smoke was being sucked out of the tunnel.

Optimism rose further when a steam shovel reached the top of the tunnel, and workmen with jackhammers drilled through the concrete, causing fresh air to begin flowing into the whole tunnel. Conditions in the western half of the tunnel began to improve rapidly. Wearing the twenty-minute air packs, Captain William Malone and fireman Arthur Driscoll made their way to the west end, where they could hear voices and noise coming through the steel doors that protected the air chamber. When the doors were opened, those in the chamber immediately headed for the work tunnel. They had been confined for thirteen hours.

About eight o'clock, fourteen hours after the fire started, the survivors reached the surface. Another six hours would elapse before the last body—that of Captain O'Neill—was recovered from the eastern half of the tunnel. The final death toll stood at eleven—seven workers and four firemen. Fifty-four men—forty firemen and fourteen workers—were hospitalized, some requiring weeks of confinement. As many as seventy firemen were treated at the scene for smoke inhalation. When the situation improved substantially, the order canceling all days off was rescinded.

A coroner's jury found that all the deaths were caused by carbon monoxide poisoning stemming from a fire of "undetermined origin." This determination was made despite a report that a laborer repairing a water leak in the eastern half of the tunnel had allowed a candle to burn down, igniting some wood and sawdust. The jury came up with twenty-one recommendations for avoiding a similar disaster. Among them: place gas masks and install telephone systems in tunnels and construct emergency exits. During the inquest, the work of the fire department won deserved applause. According to Coroner Bundesen, "Seldom has a body of men exhibited the heroism of the Chicago Fire Department in the performance of duty and in the sacrificing of life as was witnessed [during the tunnel fire.]"

One of the true heroes missed out on the words of praise and much more. If Peter Pirsch anticipated that his near superhuman effort to get his prototype smoke ejector to the scene, then witness its life-saving performance, would lead to its purchase by the department, he didn't take into account a variation of the cynical adage about human behavior: no good deed gets rewarded. The department would take a pass, thank you, blaming a lack of funds stemming from the Great Depression. That's not to say the department didn't appreciate the value of the machine. Quite the contrary, it would build its own smoke ejector in its own shops on the chassis of a 1922 White Speed Wagon. The machine would go into service in February 1932, ten months after the tunnel disaster.

IN THE SHADOW OF THE O'LEARY BARN

TAYLOR STREET ARSON
SEPTEMBER 29, 1935

Those who touched off the Curran Hall fire had no problem with the reckless endangerment they inflicted on the firemen who fought and died battling the flames. Other arsonists at other fires have not only endangered firemen but also anyone else who happened to get in the way, including children.

On Sunday night, September 29, 1935, several families were sleeping on the top two floors of a three-story brick building at 558 West Taylor Street on Chicago's near West Side. The tenants were Italian immigrants, some of whom could not speak English. The first floor was occupied by a grocery store operated by forty-five-year-old Frank Vitale, also an Italian immigrant. Vitale and his two children, twelve-year-old Anthony and eleven-year-old Rose, lived behind the store. The building dated back to the years just after the Great Chicago Fire of 1871. That conflagration had begun in the barn of Patrick and Catherine O'Leary in the block directly across the street from the building. Today, that block is the site of the Quinn Chicago Fire Academy.

At approximately 11:00 p.m., an explosion tore through the grocery store. Its windows were blown out, and the street was littered with cans of food, other food items and store fixtures. The explosion was quickly followed by flames that spread rapidly to the upper floors. For those sleeping above the store, it happened so fast that there was little chance of escape. Later, at an inquest, through an interpreter, Therese Cappola told of losing her husband and five of their six children: "Some of the children ran to a door and opened it and

An arson-for-profit plot in the shadow of the Great Fire of 1871 went awry, taking a heavy toll of lives. *Courtesy of Alex A. Burkholder.*

the flames swept in," she said, "the smoke was choking me. I saw an open window so I threw the baby out and jumped." Miraculously, the baby and his mother were not seriously injured.

Firemen rescued fourteen unconscious adults and children, some of whom had suffered serious burns. A total of ten people were killed, including the Cappola children and a sixteen-year-old girl.

Frank Vitale was not there when the explosion occurred, and his two children were staying at his sister's house. Neighbors told police that he had closed the store earlier in the day when it usually would be open. The building's landlord, Chicago police sergeant Anthony Gentile, who worked at the Albany Park station on the city's Northwest Side, told detectives that Vitale was a troublemaker and refused to move out. There was no doubt that Vitale became an arson suspect when police learned that the grocery store was not doing enough business and the store owner stood to collect $3,000 in fire insurance. He broke down during questioning by police and implicated two other men in the arson-for-profit scheme.

According to the storeowner, he asked a nephew, Joseph Vitale, to find someone to set the fire. That someone was a small-time alcohol peddler, thirty-six-year-old Joseph Di Chiari, who agreed to accept $100 after the

On May 20, 1943, an Army Air Corps B-24 bomber on a training flight from Fort Worth, Texas, to Chicago Municipal Airport (now Midway Airport) crashed into a giant natural gas holding tank at Seventy-third Street and Central Park Avenue, killing all twelve aboard. Conditions were rainy and foggy. A 4-11 alarm was sounded for the explosion and fire. A wheel from the bomber is in the foreground. *Courtesy of the Fire Museum of Greater Chicago.*

arson was carried out. Di Chiari was told to set the fire on that Sunday afternoon when the store had closed early. When the arsonist failed to set the blaze in the afternoon, he told the irate storeowner that "there were too many children around." Di Chiari came back later with fifteen gallons of gasoline. After pouring it around the store, he lit the accelerant. The amount of gasoline proved an overkill, with the arsonist barely escaping with his own life.

Frank Vitale and Di Chiari were sentenced to 99-year prison terms. Oddly enough, Joseph Vitale, the man who had the smallest role in the arson plot, received a 199-year sentence. Frank Vitale served 27 years behind bars before dying at Menard Correctional Center at Chester, in southern Illinois, on November 28, 1962. Officials there said he had been a model prisoner who never broke a prison regulation.

ANOTHER LESSON NEVER LEARNED

THE GENERAL CLARK AND LASALLE HOTEL FIRES
JANUARY 16, 1945, AND JUNE 5, 1946

It was just past midnight on January 16, 1945, when the Main Fire Alarm Office received the signal that Box 16 at Clark and Lake Streets had been pulled. The office immediately struck the box, which was literally around the corner from the quarters of Engine Company 13 and Squad 1 at 219 North Dearborn Street. Arriving at the box only moments later, firemen found a fire raging in the lobby of the six-story General Clark Hotel at 217 North Clark Street. The seventy-five-room, low-rent hotel was fully occupied, and some guests were already at upper-floor windows pleading for rescue.

Within sixteen minutes of the initial "cold" box alarm, the fire had been raised to a 4-11 alarm. A woman had jumped to her death from an upper-floor window. At least three people had jumped safely into fire nets, and at least a dozen guests were brought down by ladders. Others used fire escapes to reach safety. But hours later, after the fire on the upper floors had been brought under control, the bodies of thirteen guests were discovered. In addition, at least eight people had been injured. A six-man coroner's inquest jury ruled the deaths accidental. However, the jurors blamed the fatalities on an open stairway, which permitted gases, smoke and flames to quickly spread upstairs, trapping some of the guests. Despite the brief flurry of activity by the inquest jury and an investigation by a city council subcommittee, no major reforms were enacted to make hotels in Chicago safer. It would take less than a year and a half for a major fire to strike another Chicago hotel. The LaSalle Hotel was in the heart of the financial district, and a fire there would take many

173—La Salle Hotel, Chicago

The LaSalle Hotel, scene of the greatest loss of life in a Chicago hotel fire. *Courtesy of the William R. Host Collection.*

more lives than were lost at the General Clark. The LaSalle had almost nine hundred guest rooms and was located at the northwest corner of LaSalle and Madison Streets with entrances on both thoroughfares. The entrances led to a lobby with a mezzanine. The twenty-three-story building was less than half a mile south of the previous tragedy.

There were some 1,200 guests and hotel employees at the LaSalle on June 5, 1946. As was the case at the General Clark, flames broke out in the lobby area shortly after midnight. The Main Fire Alarm Office received a telephone call reporting the fire and, at 12:35 a.m., gave the alarm to Engine Company 40, Truck Company 6 and Chief Eugene Freemon of the First Battalion in their quarters on North Franklin Street, less than half a mile from the hotel. Also responding were Squad 1 and a Fire Insurance Patrol rig.

On his arrival, Chief Freemon found the entire lobby charged with smoke and fire. A box alarm was requested and followed immediately by a 2-11. Ten minutes after the original alarm, the fire had escalated to a 5-11. Later,

The well-laddered Madison Street side of the LaSalle Hotel, designed not only to get guests out but also to get firemen in. The intense fire still being fought in the lobby forced other firemen to enter floors above there to rescue trapped guests and stop the spreading flames. *Courtesy of the Ken Little Collection.*

six special calls would bring the total apparatus on the scene to sixty-two, including thirty-three engines, eight trucks and ten squads.

In an amazing display of rescue work, firemen brought more than 150 people down ladders while more than 900 were guided down rear stairways and outside fire escapes. More than 50 who had fallen victim to gases and smoke were revived. But the death toll would still reach 62. All were victims of anoxia and carbon monoxide poisoning, not flames. Among the 300 firemen who fought the blaze, there was one fatality, Chief Freemon, who, like the other victims, succumbed to smoke and gases. Freemon had returned to the fire department only eight months earlier after serving for two years as a navy officer in World War II and winning a citation for heroism. A temporary morgue was set up in the first floor lobby of city hall, a block north on LaSalle Street.

Each hotel fire exposed common problems. For one, there was considerable delay in calling the fire department. An open stairway at the General Clark led to fourteen deaths. At the LaSalle, open stairways from the lobby were blamed for sixty-two deaths. Careless smoking may have sparked the LaSalle tragedy, but no specific cause was ever determined for either fire. Nevertheless, if significant action had been taken after the first fire, the second might not have happened. Ironically, early plans for the La Salle, which was built in 1909, specified the placement of fire doors in the corridors at the stairway openings. Later plans deleted the fire doors.

THE HEAVY COST OF A BOTCHED RENOVATION

THE HABER CORPORATION FIRE
APRIL 16, 1953

Although the calendar said it was spring in Chicago on Thursday, April 16, 1953, the weather made it feel more like winter. The Weather Bureau forecast was "mostly cloudy, snow flurries late this afternoon or tonight, high 44 degrees." To make matters worse, northwest winds were expected to reach thirty-five miles per hour.

Despite the weather, the White Sox would manage to play their home opener in the afternoon at Comiskey Park on the South Side before only 11,354 fans. The bats were as cold as the weather. Lefty Billy Pierce gave up only one hit as he shut out the hapless St. Louis Browns, 1–0. At the same time, the Sox managed to get only two hits off veteran pitcher Harry "The Cat" Brecheen, but they were enough for victory. The opening day festivities were dampened by the cold but not nearly as much as by a tragedy unfolding on the near North Side.

At 8:46 a.m., Engine Company 4, Truck Company 10, Squad 10, the Third Battalion and Fire Insurance Patrol 5 were dispatched to an explosion and fire at 908 West North Avenue, about half a mile from the engine's quarters on North Halsted Street. Engine 4 was still running with a 1928 Seagrave thousand-gallon-per-minute pumper. The company's single-engine house had been built in 1884, and there was concern that the wooden apparatus floor might not be able to support the weight of a new, more modern rig.

As a result of the number of calls received and what was being reported, the Main Fire Alarm Office struck Box 897 for the fire, sending three

additional engines, another truck company, a water tower, another battalion chief and a division marshal to the scene.

When Engine 4 turned onto North Avenue, Captain John Sullivan and his crew immediately knew they had a battle ahead of them. Huge clouds of black smoke, pushed by those thirty-five-mile-per-hour northwest winds, had cut visibility on the thoroughfare to near zero. Sullivan, recalling where a good hydrant for the lead out was located, got off the pumper to safely guide his engineer to the spot.

On the north side of the street, flames were raging in a four-story factory building with an attached one-and-a-half-story structure to the east. Arriving firemen found injured victims who had jumped from third-floor windows to the street and to the roof of the adjoining building. Within fourteen minutes of the initial alarm, the bar was raised to a 5-11. Dozens of companies were battling the flames.

The factory was occupied by the Haber Corporation, a manufacturer of electrical appliances and parts. The structure was under renovation, but dozens of company employees continued to work in the building. Many apparently were unaware that one of two stairways had been removed and a fire escape moved from the south wall to the east wall. The realignment of the fire escape meant that means of flight ended on the roof of the smaller building with no further provision for reaching street level other than jumping. Injured employees said an explosion was followed by fast-spreading flames.

"People were running around, their shirts and hair burning," said a female employee. "They were human torches. I didn't know which way to run, so I followed the crowd."

Another woman also told of the panic on the third floor: "Smoke immediately began to fill the room, and everyone ran for the fire escape. Some of the women fell and were trampled."

A witness told of the fire's rapid spread: "In just a second it seemed fire burst out of all the second-floor windows. In another second, a woman jumped from a third-floor window to the roof of the one-and-a-half-story receiving department."

Another onlooker described the horror, telling of a man, with all his clothes burned off, appearing at a third-floor window then jumping out.

At least thirty-four persons were reported missing. Firemen searched through the ruins for four days before recovering all the bodies. The death toll climbed to thirty-five when one of the thirty-seven injured died in Augustana Hospital.

Chicagoans were stunned by the tragedy. They waited for answers from a fourteen-member so-called Blue Ribbon Jury impaneled for an inquest by the

Firemen battle the flames at the Haber Corporation. Note the canopy at street level designed to keep pedestrians from being injured by falling construction material and debris. It hindered firemen from entering the building and forced them to make only an outside attack against the flames. *Courtesy of the Jim Rzonca Collection.*

Cook County coroner. During five days of testimony, the jury was told that ten sections of the Chicago building code were violated by the Haber Corporation and the contractors it employed to do extensive work in the building. Among the violations was failure to obtain city permits for the work.

The first chief officer on the scene, Chief Frank Thielmann of the Third Battalion, said the death toll would have been considerably lower if one stairway had not been removed and the fire escape relocated.

A state safety inspector blamed the explosion on the failure of the building's ventilating system. He contended that the failure resulted in an accumulation of aluminum dust in the air ducts. The dust was touched off by a fire near a metal buffing machine on the first floor.

An owner of the Haber Corporation, Titus Haffa, described at the time as a "wealthy Chicago industrialist," told the jurors that the fire was "just a big mystery" to him. The sixty-year-old Haffa at one time owned more than a dozen companies.

During the 1920s, the colorful Haffa delved into politics as a protégé of Chicago mayor "Big Bill" Thompson, the last Republican chief executive of the city and a man not remembered as a pillar of virtue. In 1927, as a

Thompson supporter, Haffa was named alderman of the Forty-third Ward by the city council. The controversial selection occurred after the council voided a runoff election that Haffa's opponent apparently had won. The next year, Haffa was indicted on charges of violating prohibition laws as part of a "5,000,000 Bootlegging Ring." His aldermanic career was cut short in 1929. Seeking reelection, Haffa finished third, with the man he defeated two years earlier claiming the seat.

Haffa was convicted of the prohibition charges in 1931 and served seventeen months in federal prison. His clout became apparent in 1945 when President Roosevelt granted him executive clemency for the 1931 conviction. By 1964, Haffa's personal fortune was estimated as high as $100 million, making him one of the richest men in Chicago.

On May 5, 1953, nineteen days after the fire, the Blue Ribbon Jury ruled the blaze "accidental." Although agreeing that Haber and two companies involved in the renovation were negligent, the jurors could not agree on the extent of the negligence. As a result of the fire, injured persons and heirs of some of the dead filed thirty-seven damage suits. All the suits were settled two and a half years after the tragedy for $659,000. All but $107,000 was covered by insurance.

Two other fire deaths that occurred elsewhere in Chicago on April 16, 1953, were considered "collateral damage" from the Haber fire. While the factory was burning, flames broke out two and a half miles away in a residential building at 1655 North Washtenaw Avenue, at the southeast corner of Washtenaw and Wabansia Avenues. On the northeast corner stood the quarters of Engine Company 111. Those firemen couldn't respond because they were called out to the Haber fire on the 4-11.

A mentally challenged fifteen-year-old boy failed in an attempt to report the second fire. Running to the nearby firehouse and not seeing the big, red 1950 Pirsch pumper in its quarters, the teenager was incapable of calling for help. He did not notice an off-duty fireman, Joseph Morrison, working on his personal car in the single bay of the firehouse. Morrison was finally alerted by cries of "Fire!" from across the street. After reporting the fire to the alarm office, Morrison ran across the street with a ladder and began rescuing children. He and others saved nine, but not all. Two youngsters staying in an unlicensed child-care facility on the second floor burned to death.

In another postscript to the Haber fire, a 4-11 alarm was sounded on August 8, 1979, for a blaze that gutted a vacant three-story building at 864 West North Avenue. Formerly used by the company, the building was located next door to the site of the 1953 fire.

16

REVENGE

THE SEELEY CLUB ARSON
DECEMBER 11, 1965

In 1935, ten people, including five young children, were killed because a grocery store owner wanted to collect on his fire insurance. In another tragic case of arson thirty years later, the motive would be revenge.

On Saturday night, December 11, 1965, Robert Lee Lassiter, a laborer, was drinking at the crowded Seeley Club at 2026 West Madison Street, along Chicago's skid row. A week earlier, he had celebrated his twenty-fifth birthday. Everything was fine until Lassiter took out a large switchblade knife and began showing it off. Eddie Gaston, a thirty-eight-year-old waiter at the club, asked Lassiter to put it away. The men exchanged words, and the matter escalated to a brief physical encounter after which Lassiter was told to leave the place. He did not go quietly. "I'll be back and they're goin' to get it!" he shouted.

Outside, Lassiter walked a short distance to a service station where he purchased two gallons of gasoline and headed back to the club, can in hand. Once there, he poured the gasoline into the doorway and left a trail across the sidewalk to the gutter.

Not having a match, Lassiter asked a passerby for one, saying he wanted to light a cigarette. Instead of doing that, he dropped the match into the gasoline, which quickly ignited the inside front of the club.

"I saw many persons with their clothing burning," said a club employee. "They cried and screamed and begged for help."

There was a rush for the back door, where patrons discovered it locked. Later, firemen would find victims piled up in front of the door. On their arrival, firemen found flames shooting out of the club's front door and windows.

Lassiter left the scene, walking the four blocks to where he lived at 127 South Wood Street. He went to bed, quickly falling asleep.

The fire he set left thirteen people dead—six women and seven men, including Eddie Gaston. The dead ranged in age from eighteen to forty-four. Another twenty-two people were injured, half of them in serious to critical condition at Cook County Hospital.

It did not take police long to focus on Lassiter as the arsonist; he was known in the neighborhood. He worked for Advance Electric Company at 2033 West Madison Street, almost directly across the street from the Seeley Club. Police went to Lassiter's address, where they awakened him and took him in for questioning. After three hours of questioning, he admitted to setting the fire. "I just got mad," said the arsonist. "They shouldn't have thrown me out."

It took more than fifteen months before his trial began. Approximately 350 prospective jurors were questioned without a jury being selected. Many of them knew of the heinous crime. Lassiter's attorney said his client could not get a fair trial and waived his right for a trial by jury. Lassiter's fate would be decided by Criminal Court Judge Archibald Carey Jr., who rejected an insanity plea after psychiatrists representing the prosecution and the defense could not agree on whether Lassiter was able to distinguish right from wrong. To no one's surprise, Lassiter was found guilty.

On April 28, 1967, Judge Carey sentenced him to 100 to 150 years in prison for each of the thirteen murders. The sentences would run concurrently. According to the judge, Lassiter had shown a "wanton and callous disregard for others." As it turned out, he would serve nowhere near the sentence imposed.

On January 24, 1984, the Illinois Prisoner Review Board released Lassiter on parole. Including the time Lassiter spent in Cook County Jail awaiting trial, he had served eighteen years, one month and nineteen days behind bars for the murders of thirteen people. In the mid-1980s, the seriousness of a crime was not considered when deciding whether a parole would be granted. Instead, the board would look at the institutional adjustment of the convict and his plans if granted parole. Since then, that policy has been changed.

Lassiter's freedom did not last five years. He died on October 5, 1988, two months short of his forty-eighth birthday, in the small western Alabama town of Lavaca, far from the scene of his notoriety. He came to a violent, instantaneous end, but not at human hands. His death certificate shows he suffered "blunt force injuries to chest and neck" when a tractor he was driving overturned on him. According to the death certificate, Lassiter was farming his own land. It also says he left a widow.

"BUILT FOR AN ETERNITY"

THE MCCORMICK PLACE FIRE
JANUARY 16, 1967

The Chicago Fire Department, during its formative years, endured the burden of coping with a water delivery system that often was mediocre at best, although, ironically, one of the Great Lakes could be found at its doorstep.

In 1871, Chicago's valiant firefighting force was left powerless against the city's most famous, or infamous, conflagration when its water-pumping station was destroyed by the fast-spreading flames. In the Stock Yards Fire of 1910, Chicago's fire chief, along with twenty of his men and three others, were killed by a fire left unchecked because water had been shut off and was not immediately available. Even when water finally did begin to flow, its low pressure hampered the fight. In 1922, the lack of a high-pressure water system to protect the congested area just west of the Loop—the very heart of Chicago—would seriously hamper firemen fighting a fast-moving conflagration that threatened the West Side. Among buildings destroyed or heavily damaged was the fifteen-story headquarters of the Burlington Railroad. By the time of the Stock Yards Fire of 1934, water availability in that critical area had greatly improved. Construction of the new pumping station at Fiftieth Street and Western Avenue enabled firemen to ultimately control the wind-whipped flames that had consumed a major portion of the yards.

One would think that Chicago's water woes had ended in 1934, but that was not the case. The fire department's problems with water availability would extend into more "modern" times. Those problems would crop up

again during two fires that, to this day, rank among the most destructive, in financial terms, in the city's history.

The first destroyed probably the finest (from a utilitarian standpoint) and largest building of its type in the world. The McCormick Place Exposition Center was completed in 1960 to the resounding praise of Chicagoans and visitors alike. According to the *Chicago Tribune*, "Such words as monumental, colossal, even stupendous are not out of place when writing about the exposition center. It is larger than the Circus Maximus of ancient Rome and more durable than the Coliseum, which was built, said Edward Gibbon, for an eternity, and still stands as a noble ruin." The newspaper went so far in its comparisons to antiquities as to predict that the exposition center "should endure longer than the pyramids of Egypt."

The *Chicago Tribune* can probably be forgiven the hyperbole because the structure got named for the paper's late, famed publisher, Colonel Robert R. McCormick. His early support for the exposition center helped generate the legislative and financial backing that made the building possible. The paper's campaign for a new convention hall dated back at least to the 1920s, and that early push was culminated by passage in June 1927 of a referendum for a $15 million bond issue to finance construction. However, the Illinois Supreme Court upheld a taxpayers' suit to overturn the vote on the grounds that voters had been given insufficient notice. The *Tribune* and other supporters of an exposition center came back in 1951, 1953 and 1955 to plug for the necessary legislation in Springfield. Even after McCormick's death in 1955, the paper's support remained steadfast. Some suggested that a naming rights deal had been struck between the arch-Republican *Chicago Tribune*, implacable foe of all things Democratic, and Chicago's Democratic-controlled city hall. It posed the classic marriage of convenience: both camps, including incoming Mayor Richard J. Daley, wanted a lakefront center. Groundbreaking took place in September 1958.

McCormick Place was built despite the opposition of conservationists and architectural purists who complained that the huge structure and its sprawling parking lots imposed an eyesore along Chicago's picturesque lakefront. They cited a pledge expressed by three long-forgotten state-sponsored developers in 1836 that the lakefront is "public ground—a common to remain forever open, clear and free of any buildings, or other obstruction whatever." The speakers may have been forgotten, but their words lived on. Nevertheless, as the saying goes, that was then, and this is now. As Mike Royko notes in *Boss*, his profile of Mayor Daley, "[The *Chicago Tribune*] pushed so hard in Springfield for enabling legislation that one

angry legislator demanded on the floor that the *Chicago Tribune*'s political editor [George Tagge] be required to register as a lobbyist. Between the *Chicago Tribune* and *Daley News*, the conservationists were beaten and it was built. Architects and most people with two eyes hailed it as one of the ugliest buildings ever seen—a shapeless mass of concrete, squatting like a gray sow along the blue waters of Lake Michigan." McCormick Place became known among insiders as "Tagge's Temple."

Expensive as well as huge, McCormick Place carried a price tag of $35 million. Built on three levels, it extended almost a quarter mile long, a city block wide and covered some ten acres along the lakefront at Twenty-third Street. In fact, it occupied land once used for the 1933–34 World's Fair.

McCormick Place was operated by the Metropolitan Fair and Exposition Authority, whose board members were appointed by the governor and mayor with a heavy emphasis on political clout. The southern end of the building was occupied by the Arie Crown Theater, which spanned all three levels and could seat five thousand. The main exhibit hall north of the theater was located on the third level with a high ceiling. It covered 320,000 square feet, or the equivalent of six football fields. There was enough space for three smaller trade shows to operate at the same time or one huge show that embraced the entire exhibit area. The second or mid-level included the theater foyer, a restaurant, a cafeteria, banquet and meeting rooms, lounges and offices. The bottom level contained some 180,000 square feet of exhibit space in addition to other uses—such as food preparation and storage facilities, rooms for mechanical equipment and the theater's dressing rooms and orchestra pit.

One of the big events held at McCormick Place was the National Housewares Manufacturers Association Show. In the early morning hours of bitterly cold Monday, January 16, 1967, the housewares show was only hours away from opening. In the building were janitorial personnel performing a final cleanup, some maintenance people and numerous private security guards. The show was expected to attract thirty thousand visitors during its week-long run at the six-year-old exposition center. It was open to industry people only, not the general public. Some 3,700 booth spaces were occupied by more than 1,200 exhibits, almost equally divided between the main hall and the smaller-capacity bottom level.

Shortly after 2:00 a.m., two janitors in the main hall saw smoke coming from the rear of a booth occupied by a manufacturer of kitchen gadgets. The booth was located along the west wall, just north of the main entrance. The janitors found a small fire had started in the vicinity of the electrical

wiring connections, close to where packing crates and cardboard boxes were stored. The janitors attempted to beat the fire out with a broom and a piece of carpeting. They also used at least two pails of water and some portable fire extinguishers without success. The fire began spreading to other booths when a security guard called the fire department at 2:11 a.m. The call to the fire department was delayed at least six minutes.

Engine Company 8, Engine Company 9, Truck Company 4, Fog Pressure 12 (a small, two-man unit carrying three hundred gallons of water) and the chief of the Ninth Battalion, Ted Latas, were given the still alarm to "the north end of McCormick Place." Because of the significance of the exposition center, the Main Fire Alarm Office automatically struck Box 798, sending two additional engines, another truck company, a fireboat, a squad, a two-unit snorkel squad, a salvage squad, a snorkel and the first division marshal to the fire. (A snorkel is an apparatus employing an eighty-five-foot vertical articulated boom attached to a hose line.) Also responding were two civil defense units manned by trained volunteers.

When companies responding to the still alarm arrived at the entrance at 2:14 a.m., they could see flames through the glass doors and a metal freight door glowing red about twenty-five feet to the north. At 2:16 a.m., Chief Latas called for a 2-11 alarm. About a dozen booths were in flames at that time.

On arrival, Engine Company 8 hooked up to a hydrant, and on Chief Latas's orders, firefighters from the engine and Truck Company 4 began leading out two hose lines into the building. Meanwhile, the crew of Fog Pressure 12 had entered the building with their two smaller high-pressure lines and began attacking the fire. The fog pressure's three hundred gallons of water were used up quickly, and the other two hose lines were being played on the fast-spreading flames when, after only a few minutes, they went dry. The flames began to surround the firefighters, forcing them to flee for their lives. Latas called for a 3-11 at 2:20 a.m. Shortly before the third alarm, Box 795 on the northeast side of the main exhibit hall was transmitted to the alarm office. Afterward, the body of thirty-year-old security guard Kenneth Goodman, the fire's only fatality, was found in the rubble near the box's location. It was believed that he pulled the box while unsuccessfully attempting to locate an exit.

Of the seven hydrants on the west side of the building, only two turned out to be operable. Firefighters at first believed the inoperable hydrants were frozen. Later investigation would show that was not the case. Even worse, the main exhibition hall had no sprinklers, ostensibly because city code and building industry standards didn't require them for that type of operation.

Strong winds off Lake Michigan created frigid conditions for firefighting on that side of McCormick Place. A pumper and a snorkel are both heavily covered with ice. Firefighters struggled to keep their apparatus from sliding into the lake, resulting in the birth of a fascinating urban legend. *Courtesy of the Chicago Fire Department.*

The building contained more than 1,100 sprinklers, but they protected only about 8 percent of the space. Later, experts would state that a sprinkler system could have saved the main exhibit hall. As a result of the delay in calling the fire department, the lack of functioning hydrants and the absence of sprinklers in the main hall, McCormick Place was doomed.

The fire had reached five-alarm proportions twenty minutes after the initial telephone report. Twenty-one engine companies, three fireboats, five truck companies and at least seventeen other pieces of fire apparatus, including

squads and snorkels, were on the scene or responding. After the hydrant problems, firemen had to resort to "going in line" to get water. This time-consuming procedure involved the use of long hose relays from one engine company to another to obtain water from the nearest sources, which in this case included Lake Michigan, the two working hydrants outside McCormick Place and hydrants along South Parkway (Reverend Martin Luther King Jr. Drive), about a quarter mile west of the fire. Numerous pumpers took part in this operation.

At 2:48 a.m., fire commissioner Robert Quinn, who had taken command, called for a special alarm for an additional ten engine companies and all of the department's remaining nine squads. About this time, the building's roof over the main exhibit hall began to collapse. This unexpectedly quick setback was later blamed on the failure during construction to fireproof structural steel members more than twenty feet above the floor. Those steel members were supporting the roof. The unprotected steel above that level could not sustain the extreme heat and resulted in structural failure. There was also criticism that fire walls were not provided to subdivide the large exhibition areas. Fire walls would have kept the flames confined and not allowed them to rapidly spread throughout the main exhibit hall.

In addition to temperatures in the mid-teens, firefighters had to contend with a bone-chilling wind off the lake. On the eastern side of McCormick Place, only about ninety feet of sloping terrain separated the building from the water. No road or hydrants were located along the east wall. There was not much room for fire suppression operations, making the fireboats essential. The spray from the powerful boat streams created icy conditions and an unusual problem for the men. Only four engines wound up drawing water from the lake, and because of the sloping landscape and the vibration caused by the pumping activity, two of them had to be secured to trees with rope to prevent them from sliding into the water. A snorkel narrowly avoided that fate. Nonetheless, an interesting urban legend was born that night. The story goes that one engine actually did slide into the lake, went unrecovered and remains there today. Interesting, perhaps, but not true. Another urban legend, possibly true, has a colorful and irreverent Chicago reporter congratulating Commissioner Quinn for preventing Lake Michigan from catching fire.

The relentless pumps of the three fireboats were able to provide water for hoses on land in addition to their deck guns, although getting the boats to the scene and into operation ate up precious time early in the fire fight. The *Joseph Medill* (Engine Company 37, named ironically for an early

Chicago Tribune editor and part owner), which responded to the box call, had to leave its berth in the Chicago River downtown, pass through locks to enter ice-littered Lake Michigan and then travel almost three miles before reaching the scene at 2:53 a.m., forty-two minutes after the initial alarm.

Shortly after 3:30 a.m., new fires were discovered in the lower-level areas. These fires were sparked by molten aluminum, which had flowed down through an open expansion joint in the floor of the burning main hall to a room on the mid-level, causing a small fire in its ceiling. The source of the molten metal was the aluminum covering on building partition panels, which had melted from the intense heat. The molten metal continued to flow down from the mid-level through another open expansion joint to the bottom-level exhibit area, where it started a much more serious fire, which was fought with hose lines from engines and fireboats. Poor accessibility, a lack of ventilation and a large quantity of combustible contents made the new fight extremely difficult. The lack of ventilation also forced firefighters to work in relays. Because of the smoke and heat, firemen could work the hoses for only a short time before they had to be replaced by others and these, in turn, by more new troops.

About 60 percent of the booths on the bottom level were destroyed or damaged by fire, with the remainder sustaining heat, smoke and water damage. The fire department was criticized for not discovering the fire sooner but praised for its handling once it became aware of the fire. Meanwhile, the Arie Crown Theater at the south end was spared from destruction. Credited with preserving the theater were a combination of factors: an "intervening division wall," firefighters operating hose lines, the venting of heat through the collapsed roof and the exhaustion of burnable materials in the main hall.

Commissioner Quinn felt himself under great pressure as he experienced one of the worst nightmares of his long career with the department, which dated back to 1928. Quinn had been named commissioner by his boyhood Bridgeport neighborhood friend Mayor Daley in 1957. Although Quinn was a Daley favorite, the thought must have crossed his mind that the destruction of the exposition center, the mayor's prized lakefront jewel, was happening on his watch, and he might somehow take the blame for it. With that in mind, Quinn was pulling out all the stops. Quinn issued an order that would leave fire alarm operators scratching their heads. Was he requesting a general alarm that would basically empty out all of the city's 125 firehouses and send all the fire apparatus to McCormick Place? Quinn's controversial order was relayed by one of his second deputy marshals over the two-way radio.

Robert J. Quinn served as Chicago fire commissioner for twenty-one years. The disastrous McCormick Place fire was only one incident during his tumultuous leadership, which included the Our Lady of Angels school fire that left ninety-five students and nuns dead and the fiery riots of 1968 that strained the fire department to its limits. *Courtesy of the Ken Little Collection.*

"By orders of 2-1-3 [Quinn's numerical signature] any available equipment you have anywhere near the fire, send them in immediately, we need them!" the deputy fire marshal said.

The Main Fire Alarm Office senior alarm operator was confused. "You're saying 'any available,' you're not specifying?" he asked.

"The Commissioner wants engines in here. He wants any trucks, any squads, trucks or engines that are available. Get 'em in here!"

Unsure of what to do, the senior alarm operator in charge telephoned his superior, chief fire alarm operator David Sullivan, at home. Years later, after Sullivan had retired, he confirmed the phone conversation for one of the authors of this book. According to Sullivan, he told the senior operator that he would not allow the city to be left unprotected because of what he considered an already lost cause. There would be no general alarm for McCormick Place.

In addition to the engine companies requested on Quinn's first special alarm, sixteen others responded on two additional specials, bringing a total of forty-seven engines. More than five hundred firefighters using ninety-four pieces of apparatus wound up fighting the McCormick Place fire, which was struck out seven and a half hours after the first alarm.

Except for the death of security guard Goodman, there were no serious injuries among those who escaped the building or the firemen who fought the gigantic blaze. McCormick Place carried almost $30 million in fire insurance. The carriers ultimately would agree to pay $22.5 million. Estimates of the actual loss varied, with $50 million appearing the most realistic, placing it among the largest fire losses for a single building in United States history.

When Chicagoans awakened that Monday morning, they were shocked to learn that during the dark hours, McCormick Place, supposedly built for the ages, had been turned into a pile of smoldering rubble. How could this have happened? Mayor Daley was one of those asking that question. Two days later, he appointed a ten-member commission, along with two ex-officio members, to determine causes and make recommendations. One of the ex-officio members was fire commissioner Quinn. The other was Daley's building commissioner, Sidney Smith.

It took the commission six and a half months to release a 28-page report, which did not come up with a specific cause. Compare that effort with the work of the Warren Commission that investigated the Kennedy assassination or the United States Strike Commission that delved into the violent 1894 Pullman Strike—ten months and 888 pages and four and a half months and 681 pages, respectively. Why did it take so long for the Daley commission to produce a 28-page report on one fire with no conclusion? The commission explained that the reason was "due to the extent of the fire damage and because the committee was refused permission, after many efforts, to interview contractor's electricians who wired the booth in question. Our investigation revealed that wiring methods used were temporary and contained many departures from recognized good practice." The notion of a contractor beholden to the City of Chicago defying a

Just as the collapse of the Twin Towers in New York on 9/11 surprised many, the quick collapse of the roof and walls at McCormick Place also came as a surprise and raised questions about its construction. *Courtesy of the Chicago Fire Department.*

blue-ribbon commission appointed by the all-powerful mayor challenges credulity. Didn't anyone at city hall think of invoking a variation of a later admonition, "You'll never eat lunch in this town again?" Many, if not most, explanations for the seemingly inexplicable in the city's public affairs come back to politics. Mayor Daley was up for reelection in less than three months. He faced Republican John Waner, who hadn't been making much headway. All of a sudden, Mike Royko wrote in *Boss*, the challenger had found an opening. "Old frame buildings burn to the ground, but not big new modern buildings. What kind of construction was it? Were the taxpayers' millions squandered on cheap shortcuts? Was the fireproofing made of tissue paper? What happened, Dick Daley?"

Waner was energized. "Firemen were tipping me off on the inadequate hydrant system out there. I was getting calls from engineers. Somebody else told me a politician [county commissioner and later county board president George Dunne] held the insurance on the place." The Republican called for an investigation. That move netted a visit from *Chicago Tribune* political editor Tagge with a demand that Waner lay off.

"He said that if I started blasting away at it, it might embarrass him and the *Chicago Tribune*, so I had to shut up. I said the *Tribune* wasn't doing anything

The financial loss suffered at McCormick Place was among the largest ever in the United States for any fire in a single structure. *Courtesy of the Chicago Fire Department.*

for me anyway. So Tagge said, yeah, but at least they weren't hurting me. So I gave up. The *Trib* runs the Republican Party in this state, so what could I do?'"

What Waner, an earnest and likable heating and air conditioning contractor, did was get a trouncing in April by more than 500,000 votes. By the time the commission report was made public, Mayor Daley, other politicians and sundry movers and shakers were too busy planning for the "new, bigger, better," more expensive and safer McCormick Place to worry about the specific cause of what happened to the old McCormick Place. After all, there were new contracts to be awarded, concrete to be poured, beams to be erected and money to be made.

Blame for the fire hydrant debacle was placed at the doorstep of the Metropolitan Fair and Exposition Authority, not the City of Chicago and certainly not its mayor. City hall veterans would have been hard pressed to recall when an unwelcome buck ever stopped on the mayor's desk. The investigative committee reported that the authority had its own unattended, underground pumping station for McCormick Place at Twenty-fourth Street and Lake Park Avenue, about a quarter mile west of the exposition center. The station was fed by a twenty-four-inch city water main. The station then pumped the water through a similar-sized underground main to McCormick

Place for fire protection and other uses. The failed hydrants just west of the exposition center were the responsibility of the authority.

Sometime in 1966, during construction of a nearby cloverleaf ramp of the Stevenson Expressway, contractors had shut off the five hydrants in question. After the fire, the center's general manager said the contractors had not reported the hydrants back in service, and an assumption was made that the contractors remained responsible for their operation. The committee took the authority to task for not pursuing the matter. The inspectors said that "theoretically" hydrants should have been inspected and tested twice a year, but no records of such activity were kept. Further, there was no routine inspection of the auxiliary gate valves. When it came to the question of why the hydrant used by the first firefighters worked and then mysteriously failed, the committee again cited the auxiliary valve. The investigation showed that the valve for the hydrant was 95 percent closed. Flow tests conducted by the committee demonstrated the hydrant failure scenario.

After a fire in an expensive, modern structure that is only six years old, the number of revisions recommended by the commission was surprising. The panel called for forty revisions to the Chicago Municipal Code, fifteen for McCormick Place itself and three for exhibits and exhibitors. The committee pointed out how fortunate Chicago could consider itself that only one fatality resulted. "Had this fire occurred eight hours later, when the exhibition hall could have been crowded with show patrons, egress facilities could have been taxed to their limit and the possibility of ensuing panic could have resulted in a great loss of life."

"WORST SINCE MRS. O'LEARY"

THE CENTRAL MANUFACTURING DISTRICT FIRE
MAY 27, 1973

C hicago would have to consider itself unfortunate again little more than six years later when an explosion and resulting fire leveled several buildings on the Southwest Side. The occurrence might have been—like the "Second Chicago Fire" of 1874, one hundred years earlier—one of the largest and most devastating fires to vanish from the city's collective memory. Once again, getting water to battle the inferno would prove the bane of responding firemen.

It was rainy in Chicago on Sunday morning, May 27, 1973. Thunderstorms lurked about; the temperature held in the upper fifties. Little traffic filled the streets shortly after seven o'clock. Most people not still asleep were waking up. One of those up and about was Southwest Side resident William Lietz, a Chicago firefighter assigned as a driver for fire commissioner Robert Quinn. Lietz was driving his own car north on Pulaski Road, heading for the Stevenson Expressway, which would take him downtown. He was scheduled to begin his twenty-four-hour shift at eight o'clock at the quarters of Engine Company 42 on the near North Side. Quinn's official car was parked there, only a few blocks from his residence.

At approximately 7:10 a.m., Lietz was on Pulaski Road at Forty-second Street when he heard a tremendous explosion. He felt the blast lift his car off the pavement. Looking west, toward an area known as the Chicago Manufacturing District, Lietz saw flames leaping high in the air, and then there was a second explosion. The initial explosion was felt as far as five

miles away. Seven western suburbs were showered with metal shards and wood splinters. At least fifty windows were reported broken in the nearby town of Cicero.

Lietz hurriedly drove on and found a telephone to report what had happened to the Englewood Fire Alarm Office, which was being deluged with calls. The Englewood office, at Sixty-third Street and Wentworth Avenue, handled all fire calls in Chicago south of Pershing Road.

At 7:10 a.m., Engine Company 34, Engine Company 65, Truck Company 54, Flying Manpower Squad 4 and the chief of the Thirty-first Battalion were given a still alarm for the location at Forty-third Street and Keeler Avenue, a quarter mile west of Pulaski. Based on the information provided by Lietz, the office struck Box 2199 at 7:11 a.m., sending two additional engine companies, another truck company, a snorkel, an ambulance and the Fourth Division marshal to the scene.

Engine 34 and Truck 54 shared quarters near Forty-seventh Street and Pulaski Road, about three-quarters of a mile from the fire. Arriving on the scene at 7:13 a.m., the engine's officer immediately called for a 2-11 alarm. The firefighters found themselves confronted by an inferno. Flames were shooting fifty feet into the air, and thick, black smoke was billowing hundreds of feet higher. One eyewitness said the plume of smoke reminded him of the eruption of a volcano.

The fire was centered in a large, one-story building at 4250 West Forty-second Place belonging to the Levey Division of the Cities Service Oil Company, a maker of printing ink. Naphtha, a highly flammable liquid used in the process, was stored in fifty-five-gallon drums in the building. To make things worse, sprinklers in the structure were of no help because the force of the explosions had ruptured the eight-inch main that would have fed them with water. Also ruptured were the mains leading to the sprinklers in other buildings in the immediate area. Miraculously, a watchman, fifty-two-year-old George Visnovsky, managed to escape the Levey building with only minor burns and cuts.

The fire spread east to the warehouse of the L. Fish Furniture Company at 4242 West Forty-second Street, which had been damaged by the first explosion. In addition, a railroad tank car containing highly flammable benzene exploded on tracks between the Levey and Fish buildings. (L. Fish was another company that seemed cursed by fire. The 1910 fire at its State Street store claimed twelve lives.) A sixty-eight-year-old watchman at the furniture warehouse, James Hill, avoided the fate of his predecessors. He hid under a desk to escape injury from falling debris. He then crawled outside to safety.

The Levey ink plant where the explosion occurred, with the ensuing fire that ravaged Chicago's Central Manufacturing District. *Courtesy of the Jim Regan Collection.*

Meanwhile, the fire also had spread west to the A&P Grocery Distribution Center at 4404 West District Boulevard and north to the Milani Foods plant at 4261 West Fortieth Street. The A&P facilities supplied non-perishable food products to 180 stores in the metropolitan area. The Milani Foods plant made salad dressings. By now, several city blocks of buildings had become raging infernos.

Commissioner Robert Quinn told reporters that the huge fire was consuming the largest area of any blaze since the one that swept the stockyards in 1934, four miles to the east. By 7:30 a.m., the fire had grown to a 5-11 alarm. However, pulling alarms was one thing, answering them another. Only sixteen engines and four trucks were at the scene or on their way. Historically, a 5-11 in an industrial district would have brought at least twenty-two engines and five trucks. But based on the recommendations of a consultant, the fire department had begun reducing the number of responses on extra alarms. Later, the department would reconsider and increase such responses.

The city couldn't seem to drive a stake through the heart of a problem that had confronted its firefighters for more than one hundred years: The hydrants in the area weren't providing enough water flow, and the streams

Similar to what happened at McCormick Place, fire companies were forced to lead out from hydrants blocks away to get enough water to battle the fast-spreading flames. *Courtesy of the Jim Regan Collection.*

firemen did find available offered no match for the enormous, fast-spreading flames. Reminiscent of the McCormick Place fire, engine companies had to begin the time-consuming process of "going in line," beginning with hydrants blocks away, to get more water on the massive fire. To accomplish this tactic, a total of twenty-two engine companies, three truck companies, six flying manpower squads and other apparatus responded on five special alarms. (Some of the assignments on those specials might also have been designed to fatten the lean responses on the earlier extra alarms.) Hoses placed over Illinois Central Gulf Railroad tracks nearby disrupted service on that line. In Monday's editions, the *Chicago Sun-Times* described firefighters that Sunday night dismantling "miles and miles of hose."

More than four hundred firemen fought the blaze, which took eight and a half hours to bring under control. Some firefighters would remain on the scene for days, wetting down smoldering areas and putting out flare-ups. There were no fatalities and only four non-life-threatening injuries. Visnovsky and two firefighters were among the casualties.

At first, speculation arose that a bolt of lightning might have sparked the explosion, but that theory was later discounted. The state fire marshal's office conjectured that a large quantity of fumes from highly flammable ingredients in the ink-making process must have accumulated, leading to the huge blast. The utter destruction caused by the explosions and fire hampered the investigation, which ultimately pinned the cause on overheating in a large mixing drum at the Levey plant.

Although the Levey building probably would have been a total loss no matter what the water flow situation, it's possible that the destruction of the other structures might have been limited if the firefighters had been able to make a more aggressive attack against the flames early on.

The water mains and hydrants in the vicinity were installed by the developers, but the city had to approve them. An engineer from the Chicago Water Department would confide later that the mains were able to provide a good "domestic" supply or, in other words, enough water for routine business operations. The engineer went on to concede that the mains were unable to provide enough water to fight a fire of the magnitude of the one that occurred on May 27, 1973, despite the presence of the high-capacity pumping station at Fiftieth Street and Western Avenue, a little more than three miles away.

Fortunately, the explosion that touched off the fire occurred on a Sunday morning. According to Commissioner Quinn, "The loss of life out there on a working day would have been tremendous. Those explosions would have trapped people, and there would have been many, many deaths." The fire did leave hundreds unemployed. Destruction of the A&P warehouse forced the company to supply its Chicago-area stores from a facility in Milwaukee and probably hastened the giant grocery chain's ultimate departure from the Chicago market.

Two days after the conflagration, a *Chicago Tribune* headline read, "Worst Fire Here Since Mrs. O'Leary," a reference to Catherine O'Leary, whose cow—so legend held—kicked over a lantern and started the Great Chicago Fire of 1871. The fire of 1973 was estimated to have caused $40 to $50 million in damage. That figure begs comparison to the estimated $25 million loss cited by the newspapers for the previous runner-up, the fire at McCormick Place. A $25 million loss at McCormick Place seems conservative by any standard. Losses not paid for by insurance, losses in show and tourism revenue and the additional funds for the much more costly new McCormick Place easily would have made it Chicago's second greatest loss.

Only sixteen days after the Central Manufacturing District fire, disaster visited another Levey ink plant, this one in Philadelphia. A fire and explosion

killed two firefighters and injured thirty-eight others after flames broke out in a three-story annex of a five-story facility. Twenty employees fled safely. Chicago fire officials noted that in Philadelphia the fire preceded the explosion, while in Chicago it was the other way around.

Fourteen firms that incurred damages in the 1973 Chicago fire sued the Levey Division of Cities Services and the Paul O. Abbe Company of New Jersey, manufacturer of the mixing drum that overheated. In October 1982, shortly before the case was finally ready to go to trial, the defendants settled for a combined $11.4 million. It was believed to be the largest private property settlement in Illinois to that time.

Could another devastating fire in Chicago be magnified because of water supply problems? An October 2011 report doesn't offer much cause for optimism. At that time, the city's new mayor, Rahm Emanuel, proposed a major increase in water rates for the many suburban residents who are served by Chicago. The additional money, according to the mayor, would be used "to help cover the cost of the city's aging water and sewer infrastructure." Much of the aging water infrastructure was built between 1890 and 1930. Over that period, some three thousand miles of pipe were laid throughout the city. One expert has asserted that the system is "crumbling" and "at the end of its useful life." That observation, from John Spatz, executive director of the DuPage County Water Commission, offers the perspective of someone who has studied the problem from both sides of the city limits. Spatz is the former commissioner of the Chicago Water Management Department. Under the right (or wrong) circumstances, a fire of the magnitude of those at McCormick Place or Central Manufacturing District could happen again. We can only hope that those circumstances never occur, or if they do, not until Chicago's firefighters don't have to rely on a deteriorating water delivery network.

BIBLIOGRAPHY

Burkholder, Alex A. "April's Hand of Death." *Firehouse*, April 1983.

Chicago Board of Fire Underwriters. *Reports*. Chicago Public Library. Municipal Reference Collection. Chicago, 1905, 1912, 1914, 1917 1919, 1920, 1922, 1925, 1929, 1931.

Chicago Daily News.

Chicago Fire Department. *Annual Reports*. Chicago: Chicago Fire Department, 1910–24.

———. *Chicago Fire Department History, 1832–1886*. Chicago: Chicago Fire Department.

———. *History of the Chicago Fire Department*. Chicago: Chicago Fire Department, 2004.

Chicago Herald.

Chicago Inter-Ocean.

Chicago Mayor's Commission. *Report of the Investigation of McCormick Place Fire*. January 16, 1967.

Chicago Reader.

Chicago Sun-Times.

Chicago Times.

Chicago Tribune.

City of Chicago. *Annual Reports*. Chicago: City of Chicago, 1909–24.

———. *Proceedings of the Special Council Committee on Investigation of the Chicago Fire Department*. Chicago: City of Chicago, 1924.

————. *Report of the Fire Marshal to the Common Council of the City of Chicago for the Fiscal Year Ending December 31*. Chicago: City of Chicago, 1923.

Corwin, Will B. *Swenie, the Firefighter*. Chicago: J.F. Higgins, 1903.

Currey, J. Seymour. *Chicago: Its History and Its Builders, a Century of Marvelous Growth*. Chicago: S.J. Clark, 1910.

Everett, Paula. *1909 Lake Michigan Crib Fire*. Personal collection.

Host, William R., and Brooke Ahne Portmann. *Early Chicago Hotels*. Charleston, SC: Arcadia, 2006.

Kiefer, Tony. *Presentation on 1909 Lake Michigan Crib Fire*. Chicago: Underwater Archeological Society of Chicago, June 20, 2011.

Little, Kenneth. *Chicago Fire Department Engines: Sixty Years of Motorized Pumpers, 1912–1972*. Chicago: self-published, 1972.

————. *Chicago Fire Department Hook and Ladder Tractors, 1914–1971*. Chicago: self-published, 1973.

Little, Kenneth, and John McNalis. *History of Chicago Firehouses*. 4 vols. Chicago: self-published, 1957–2009.

McNalis, John. *Chicago Firefighters Who Have Been Killed in the Line of Duty*. Unpublished, n.d.

McQuade, James S. *A Synoptical History of the Chicago Fire Department*. Chicago: Chicago Fire Department Benevolent Association, 1908.

Royko, Mike. *Boss: Richard J. Daley of Chicago*. New York: Plume, 1998.

Turrentine, Harold, ed. *History of the Chicago Fire Department*. Chicago: Chicago Fire Department, 2004. http://www.cityofchicago.org/dam/city/depts/cfd/general/PDFs/HistoryOfTheChicagoFireDepartment_1.pdf.

Weimann, Jeanne Madeline. *The Fair Women*. Chicago: Academy Chicago, 1981.

Wille, Lois. *Forever Open, Clear and Free: The Struggle for Chicago's Lakefront*. 2nd ed. Chicago: University of Chicago Press, 1991.

INDEX

ABOUT THE AUTHORS

Chicago native John Hogan is a published historian and former broadcast journalist and on-air reporter (WGN-TV/Radio) who has written and produced newscasts and documentaries specializing in politics, government, the courts and the environment. As WGN-TV's environmental editor, he became the first recipient of the United States Environmental Protection Agency's Environmental Quality Award. His work also has been honored by the Associated Press. Hogan left broadcasting to become director of media relations and employee communications for Commonwealth Edison Company, one of the nation's largest electric utilities. Hogan is the author of Edison's one-hundred-year history, *A Spirit Capable*, as well as two Chicago histories, *Fire Strikes the Chicago Stock Yards* (co-authored with Burkholder) and *The 1937 Chicago Steel Strike*. He holds a BS in journalism/communications from the University of Illinois at Urbana-Champaign and presently works as a freelance writer and public relations consultant.

A fire buff for most of his life, Alex Burkholder began learning about the Chicago Fire Department as a youth, riding to fires on the engines and helping to extinguish the flames. Burkholder earned a BS and MS in journalism from Northwestern University. He went on to become an Emmy award–winning investigative news producer, feature news producer, field producer and news writer/reporter for WGN-TV/Radio and ABC 7 Chicago. He has conducted a number of long-term investigations that required extensive research, writing and coordination and has written a

number of magazine articles for publications devoted to firefighting and economics. Burkholder is co-author of *Fire Strikes the Chicago Stock Yards*. He is a founding member of the Fire Museum of Greater Chicago and presently works as a freelance writer.